蔡李佛技擊法

CHOY LI FUT FIGHTING TECHNIQUES

黃宇帆 著

Wong Yu Fan

香港國際武術總會出版

Hong Kong International WuShu Association

黃宇帆國際武術文化中心

WONG YU FAN INTERNATIONAL WUSHU CULTURAL CENTRE

目　錄

CONTENT

First—Sixteenth (Unarmed Combat)

前 言
INTRODUCTORY

我是一個武者，傳播中國傳統武術，用功夫武動人生是我一生不懈追求的目標。從立志到堅守到最後的頓悟，在我眾多武緣中至今蔡李佛拳的修習對我影響甚大，而能夠跟隨蔡李佛拳泰斗黃江大師嫡傳弟子黃達華師父學藝，並成為其門下大弟子，實是萬分榮幸！

2008 年，蔡李佛拳經國務院批准列入第二批國家級非物質文化遺產。從那時開始我就想為傳播蔡李佛文化寫點什麼。無巧不成書，這個想法當年與全球第一本中英文武術雜誌《新武俠》總編輯廖廣華先生不謀而合。他多次邀請我為雜誌寫個"蔡李佛文化"的專欄。這讓我深感身上傳播蔡李佛的責任和使命之重大。因為多年的武術教育和文化傳播生涯，已經讓我深刻感受到今日的蔡李佛已經不僅是中國的，也是世界的。特別是諸多影視作品的宣傳普及作用，已經讓蔡李佛廣為人知，並且深入人心。

接到這個任務後，我沒有立刻著手去寫，而是先作了認真深入的思索和總結。因為蔡李佛越往深里學，就越覺得它的系統越大，有很多東西可以分享。而我一直覺得武術的教育和傳播最大的立足點應該在於"喚醒"，蔡李佛所講究的剛柔並濟、拳我交融、天人合一、融合了中國傳統文化儒釋道的精髓，這些都不是一兩篇文章可以闡述言傳的。紹

I am a Martial Artist. Naturally, promoting traditional Chinese Kung Fu and mastering it has become my life aspiration. A these years studying Chinese Kung Fu and enduring with a strong will, Choy Li Fut is the most influential experience in m practice. Especially studying under the Grandmaster Wong Gong's son Wong Tat Wah and becoming a principal disciple an ultimate honour for me!

In 2008, Choy Li Fut was listed as Intangible Cultural Heritage by Chinese State Council. Since then I have been thinking promoting Choy Li Fut. It's fortunate that The Editor in Chief of "New Martial Hero" (First Chinese-English Martial Art Maga zine), Mr Liu Kwong Wah shared a similar idea.

As a result, I was invited to write a column of "Culture of Choy Li Fut" for the magazine. At the same time, being a mento for so many years and seeing the influence of martial art in media, Choy Li Fut has become world known by appearir different media platforms. I have come to an understanding that it is an important task for me to participate in promotir the culture.

Writing a cultural column is a challenging task. Instead of starting it immediately, I constantly spent the time to reflect ar conclude my understanding of Choy Li Fut which is a very vast system that can be explored endlessly.

Personally, I believe "awakening the sense" of martial art is fundamental for promoting such culture. Choy Li Fut contai the basic idea of softness and hardness (Yin and Yang) but more importantly, it is infused with traditional Chinese philos phy which can be easily lost in translation through paper and words. To "awake" the sense one must practice Kung F with continuous effort to develop understanding of both physical and philosophical aspect of Choy Li Fut.

得來終覺淺，真正學習蔡李佛理解蔡李佛在於鍥而不捨的修為。

後來想想，工欲善其事，必先利其器。蔡李佛的普及很大程度有賴於其突出的技擊實用性。因為它融合了多家之長，攻防嚴謹，拳法拳理也就更為雋永深澈，能通過技擊實現拳我合一。我平時訓練也就非常注重從技擊方面入手打基礎。於是就決定從寫《蔡李佛技擊法》為切入點，開始了專欄的創作，沒想到這樣一寫就快十年了。日積月累，也就有了一些總結。

為了在推廣蔡李佛功夫文化上，能夠再盡一點綿力，我利用訓練和教學的業餘時間認真整理了多年來的專欄內容，匯編成這本書，並重新拍攝了照片、做了編輯設計，力求讓文字表達也更為簡潔、清晰。

本人功夫修為境界尚淺，文筆水平有限，但還是希望通過自己的這些訓練和實戰經驗能夠帶給大家一些參考價值。

黃宇帆
2018 年 9 月於香港

After a while, I took a step back to realise the form of Choy Li Fut is practical and applicable in combat due to its solid yet flexible structure in both attack and defence. It is because it assimilates the strength from multiple styles of Kung Fu including theories and philosophies that contribute toward the combat system. Training student daily and using combat application as a foundation, it leads me to use "Choy Li Fut Fighting Techniques" as a starting point for the magazine "New Martial Hero" to promote the culture.

Until now, it has been almost 10 years since I started writing for the magazine. Naturally, I am able to conclude the system through a different perspective. Hence, this book with illustration and revised writing will be a journey exploring Choy Li Fut explained in a robust and precise manner.

As a martial artist, it is always a pleasure to promote the culture that integrated with my daily life. Most importantly, I sincerely hope by sharing my passion for both training and combat can be an inspirational experience for every reader to interest in the principle and philosophy.

Wong Yu Fan
September 2018
Hong Kong

序一

蔡李佛拳技藝，一脈相承，賢孫黃宇帆《蔡李佛技擊法》一書出版，甚為欣慰高興，幸望更多人喜歡蔡李佛拳。

黃江
蔡李佛第四代傳人
原江門雄勝總館繼承人

Preface 1

I am extremely delighted with the release of my grandson, Wong Yu Fan's new book "Choy Li Fut Fighting Techniques" that included the precious knowledge passing down from our pioneers. I wish more people will enjoy Choy Li Fut.

Wong Gong
The 4th Generation Descendant of Choy Li Fut
Former Head of Xiong Sheng Choy Li Fut, Jiangmen, China

序二

中華武術源遠流長，博大精深。徒手搏擊法遠在明朝萬曆年間五雜組著作寫入十八般武藝。余自幼師承家父黃江習練蔡李佛門派拳法及器械，蔡李佛拳精於十八般武藝，而其中徒手搏技法尤是強項。

黃宇帆隨余學藝多年，為人謙厚，尊師重道，求學之路孜孜不倦，年方三十之時考取武術碩士一銜，多年來擔任中外很多大學的 EMBA、MBA 中國武術文化講師，兼在香港電視臺主持多個武術節目推廣傳統武術文化，在中港設立武術培訓基地，廣收門徒，開班授藝。多年來對傳承傳統武術不遺餘力，一直帶領幼苗參與國內外交流及比賽，在眾多國際賽事中奪冠。其對武術傳承之熱情及貢獻，著實令人欽佩，與其結緣成師徒，是余之福氣，此子能承擔師門傳承重責亦所托有人。

為弘揚傳統武術，宇帆傾注全力精心編寫《蔡李佛技擊法》，余衷心祝賀愛徒新書出版成功，將其所學及心得惠及大眾，讓更多人真正了解中國傳統武術文化。

黃達華

蔡李佛第五代傳人

Preface 2

Chinese Martial Arts have a long-standing history and well-established system. "Eighteen Arms of Wushu" was first recorded in Ming Dynasty under the control of Emperor Wanli to showcase the list of martial art weapons in Chinese history.

I have been studying Choy Li Fut style from my father Wong Gong (Grandmaster of Choy Li Fut) since I was a kid. "Unarmed Combat" is considered one of the "Arms" of Wushu. Choy Li Fut in another hand is exceptional in demonstrating the "Unarmed Combat" as a form of martial art.

Wong Yu Fan has been studied Choy Li Fut under me for many years. He is humble, well-mannered and passionate in pursuit of both knowledge and skills. He graduated with the First Honour as Master of Martial Art in his 30. Since then, he has been giving lectures on Chinese Martial Art Culture for EMBA and MBA students in many universities and promoting Traditional Chinese Martial Art in HKTV as a host.

He is also a Choy Li Fut master teaching in Martial Art Academy based in both Hong Kong and China. For many years, he has been a mentor for numerous students and passing the skill to the next generation. Many of his students participate in the International competition and finished with the glorious result under his training.

Yu Fan's enthusiasm in promoting and contribution to Traditional Chinese Martial Art is admirable. It is one of my greatest pleasure of having a student like him. I have high hope for him and believe him will be able to continue the legacy of Choy Li Fut in the future.

Yu Fan's book "Choy Li Fut Fighting Techniques" is written with passions and his personal experience in traditional martial art. For those who are interested in Chinese traditional martial art culture, with the knowledge that shared by Yu Fan, it will be a fantastic experience. It is always pleasing to learn from him and in here I wish him great success with the book.

Wong Tat Wah
The 5th Generation Descendant of Choy Li Fut

序三

黃宇帆先生自幼已踏上武學之路,在成長期間得多位師傅授以不同派別的內外家武術,可謂內外雙修。在多項國際賽事中都能摘冠,更經常被多間電視台和武術雜誌社認作採訪對象,實至名歸。為推廣傳統武術,年紀輕輕的他用自己的名字創立了武術文化中心,至今已經十年多了,其間他的學生在很多大賽上奪得佳績,令人刮目相看。他的成就,可說是當今年青武術家之表表者。得悉其把蔡李佛拳的技術修輯成書,作公開教材,實是讀者之福。故作為他的太極拳老師,被邀為此書作序,借此祝願他百尺竿頭,更進一步。

鄭光武

二零一八年仲夏

Preface 3

The writer of this book, Mr Wong Yu Fan (黃宇帆) studied the Chinese martial art when he was a child, he has never stopped training the Shaolin Kung Fu in China and so on continued to receive the toughest training from other masters of various field. As he was too young to win the numerous first place in the local and international tournament, he has been identified as the interviewee by few TV stations and the prestigious publications.

Mr. Wong is a renowned master, combined with his expertise, well developed skill and keen understanding of Choy Li Fut and Tai Chi Kung Fu, he has established a martial art school for more than 10 years. Since then, he took lead of his students to gain a lot of top honor in various tournament.

Being his Tai Chi master, I have the privilege to strongly recommend this book to those who want to acquire more knowledge and advance the skill of Choy Li Fut Kung Fu.

Cheng Kwong Mo

Mid Summer 2018

序四

蔡李佛拳可以說是本人幼年時習武的啟蒙拳種,內容博大精深,手法多變,步法靈活,配合前後左右上下,攻防兼備,且非常實用,其技擊之術影響至今。相識宇帆多年,此子為人謙虛上進,對功夫的追求孜孜不倦,對功夫文化的推廣不遺餘力,今見他將多年磨練心得總結整理出書,可喜可賀,這是一本非常好的蔡李佛技擊法教學書。

何沛霖
《太極九式防衛術》創始人
香港懲教署職員訓練學院戰術導師顧問

Preface 4

I have started to learn martial arts since I was a child and the Choy Li Fut style has been one of the most enlightening one for me. It is a combative system with much content and depth. With its dynamic fighting techniques and fluid footwork, together with its multi-directional approach (forward, backward, up, down, left and right), the Choy Li Fut style comprises both the offence and the defence. It is a practical martial art that is still influential today.

Having known Yu Fan for a long time, he is a modest and diligent person. He has persistence with his own improvement in martial arts, and at the same time promotes the martial art culture with all his might. The publishing of this book that is filled with the years of knowledge accumulated by Yu Fan is an event that worths celebrating. This book is very useful for learning Choy Li Fut fighting techniques.

Ho Pui Lam
Founder of Taichi Nine Self-defence Techniques
Honorable Advisor (Tactical Training in Martial Arts)
of Staff Training Institute in the Hong Kong Correctional Services Department

作者簡介

INTRODUCTION OF AUTHOR

WONG YU FAN 黃宇帆

黃宇帆國際武術文化中心創辦人，中國武術碩士，蔡李佛派黃江嫡系，蔡李佛派第五代黃達華傳人，楊式太極第五代鄭光武傳人，嵩山少林宋照峰傳人，客家拳朱家教傳人，何沛霖《太極九式防衛術》傳人，全球第一本中英文武術雜誌《新武俠》顧問編輯，EMBA、MBA 中國武術文化講師，2006 年第二屆世界傳統武術錦標賽金牌得主，2009 年香港首屆國際太極推手比賽冠軍，2010 年獲嘉許為"首屆香港卓越師傅"，曾接受《香港商報》、《0755 都市周刊》、《梅州鄉情》、《意大利武術雜誌》、《榮譽雜誌》等報刊專訪，及亞洲電視採訪、受南方衛視邀請拍攝《蔡李佛拳》教學片，2017 接受 One TV《發現香港》節目採訪，2014 年及 2017 年登上全球第一本中英文武術雜誌《新武俠》封面人物。

Master degree holder in Chinese Wushu. Founder of the Hong Kong Wong Yu Fan Wushu Cultural Centre. Lineal descendant of WONG Gong, Grandmaster of Choy Li Fut. Descendant of WONG Tat Wah, 5th Generation Instructor of Choy Li Fut. Descendant of CHENG Kwong Mo, 5th Generation Instructor of Yang's Taiji. Descendant of SONG Zhao Feng, Songshan Shaolin Sect. Descendant of Zhu Jia Jiao (Hakka Martial Art). Descendant of HO Pui Lam, the Taichi Nine Self-defence Techniques. Consultative Editor of "New Martial Hero", the global 1st Chinese and English Martial Arts Magazine. Lecturer of Chinese Wushu Cultures for EMBA/MBA courses. Gold Medal Winner of the 2nd World Traditional Wushu Champion-ship held in 2006. Champion of the 1st Hong Kong International Taiji Pushing Hands Com-petition held in 2009. Awarded for "1st Hong Kong Outstanding Masters" in 2010. Exclusive interviewee for newspapers/magazines such as "Hong Kong Commercial Daily", "0755 Xiao Fei Zhou Kan", "Mei Zhou Xiang Qing", "Italian Martial Art Magazine" and "Rong Yu ZaZhi". Interviewee for programme conducted by Asia Television. Invited as performer for teaching video called "Choy Li Fut Quan" produced by Southern Television in China. Interviewee for programme "Discover Hong Kong" produced by One tv in 2017. Cover figure in 2014 and 2017 for "New Martial Hero", the global 1st Chinese and English Martial Arts Magazine.

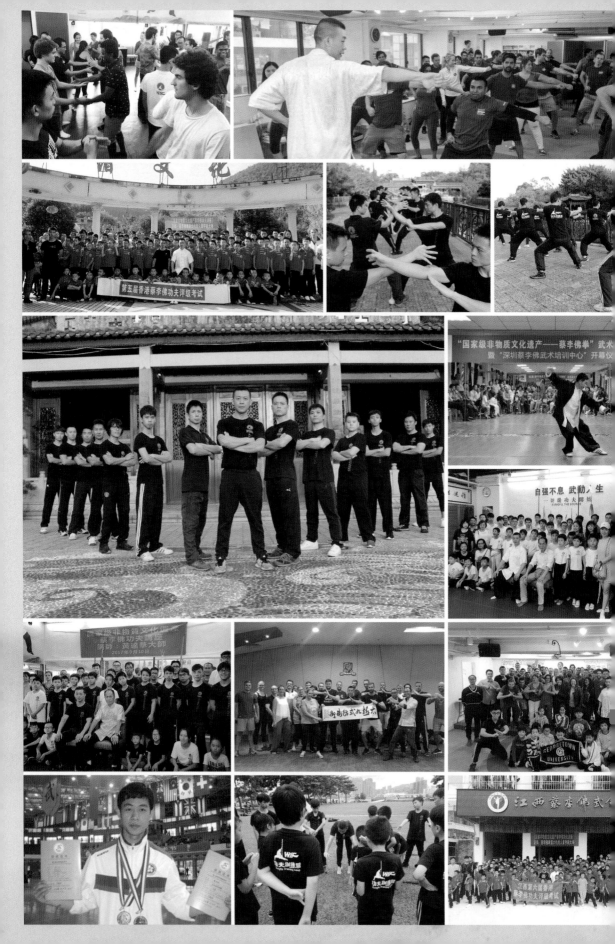

黃宇帆國際武術文化中心
WONG YU FAN INTERNATIONAL WUSHU CULTURAL CENTRE

蔡李佛拳簡介

INTRODUCTION OF CHOY LI FUT

蔡李佛拳派起源於廣東江門新會，至今已有一百八十年歷史。本派創始人是新會崖西京梅鄉人陳享，字典英，號達亭，生於清嘉慶年(西元一八零六年農曆七月初十日)。蔡李佛拳是陳享跟隨三位少林大師蔡福、李友山和陳遠護學藝後，集三家之長而形成一派。流傳至今，已經發展有非常多的分支，並分布於五大洲，習者人數非常龐大，確切數字已經難於統計。

蔡李佛派拳術以實用為主，它的訓練相當系統，內容豐富，剛柔兼修，著重攻防配合，步法靈活而穩健，發勁剛中帶柔，講究發聲與動作的配合。動作舒展大方，拳路氣勢磅礴。具有快速靈活，打法多變，勇猛且機智的風格。

2008 年 6 月 8 日，國務院 (國發 [2008]19 號) 公佈，批准文化部確定的第二批國家非物質文化遺產名錄，蔡李佛拳獲准為國家級非物質文化遺產項目 (序號 808；編號項目 VI-36)。

Choy Li Fut was found by Chen Xiang, who was born on 23 August 18, 1806, in Xin Hui, Jiang Men City, Guangdong Province. In 1836, the system of Choy Li Fut is formally established and is around 180 years old now.

Chen Xiang learns from three different Shaolin Masters, Cai Fu, Li You Shan and his uncle Chen Yuan Hu and combined his experience of varies from to create Choy Li Fut by utilising the superiority of induvial style. Nowadays, the legacy has branched out across the world and there are countless people studying Choy Li Fut.

Choy Li Fut itself is a comprehensive training system which is covering both external and internal body conditioning. In practice, it requires the synchronisation of vocal and movement, from stance and emphasis on relaxation to improve the swiftness and control. In combat, it requires nimble footwork and rapid pace adjustment in order to maintain both aggressive and defensive momentum. The flexibility and unpredictability combine with extensive motion granting its further reach and making it an effective and practical combat system in a rather sharp style.

On 8 June 2008, Chinese State Council passed the 2nd batch of Intangible heritage request from the Cultural Department. Choy Li Fut officially becomes National Intangible Heritage. (Serial No.808 Subject VI-36)

黃宇帆賢誼孫

蔡李佛拳

世代相傳

黃江題

蔡李佛第四代傳人　　　　Dedication from Grandmaster Wong Gong
原江門雄勝總館繼承人　　The 4th Generation Descendant of Choy Li Fut
黃江大師 題詞　　　　　　Former Head of Xiong Sheng Choy Li Fut, Jiangmen, China

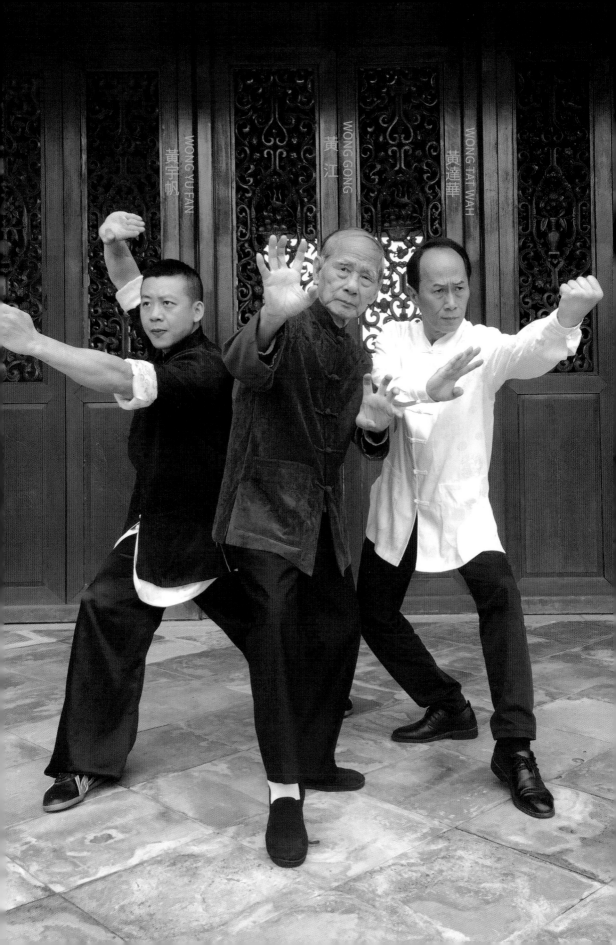

WONG YU FAN 黃宇帆 WONG GONG 黃江 WONG TAT WAH 黃達華

CHOY LI FUT

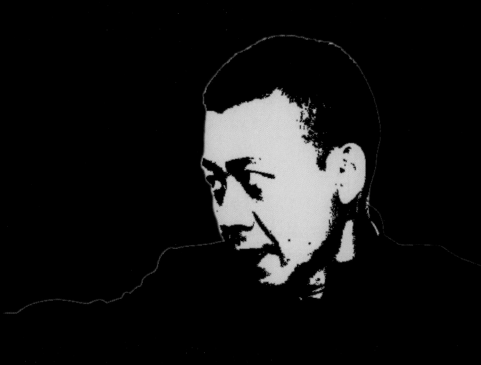

蔡李佛拳

國家級非物質文化遺產

National Intangible Cultural Heritage

手法步法示意圖
Schematic diagrams of hand form and stance

掛搥
Back Fist

撞搥
Small Upward Power Strike

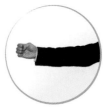

插搥
Knuckle Strike

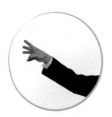

穿錨手
Piercing Anchor Hand

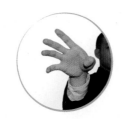

穿錨手
Piercing Anchor Hand

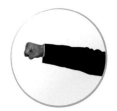

掃搥
Sweeping Fist

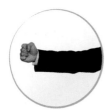

劈搥
Splitting Fist

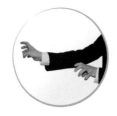

奪橋
Seizing Bridge Hands

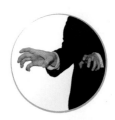

奪橋
Seizing Bridge Hands

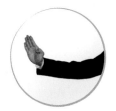

掌
Palm

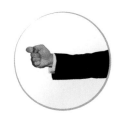

鳳眼搥
Eichhornia Knuckle Strike

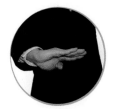

蟠橋
Coiled Bridge Palm

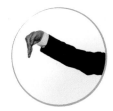

攻橋
Attacking Bridge Hand

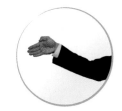

沉橋
Downward Bridge Hand

擔橋
Upward Bridge Hand

子午馬
Straight Stance

四平馬
Horse Stance

纏絲馬
Cross Stance

吊馬
Hanging Stance

跪膝馬
Kneeling Stance

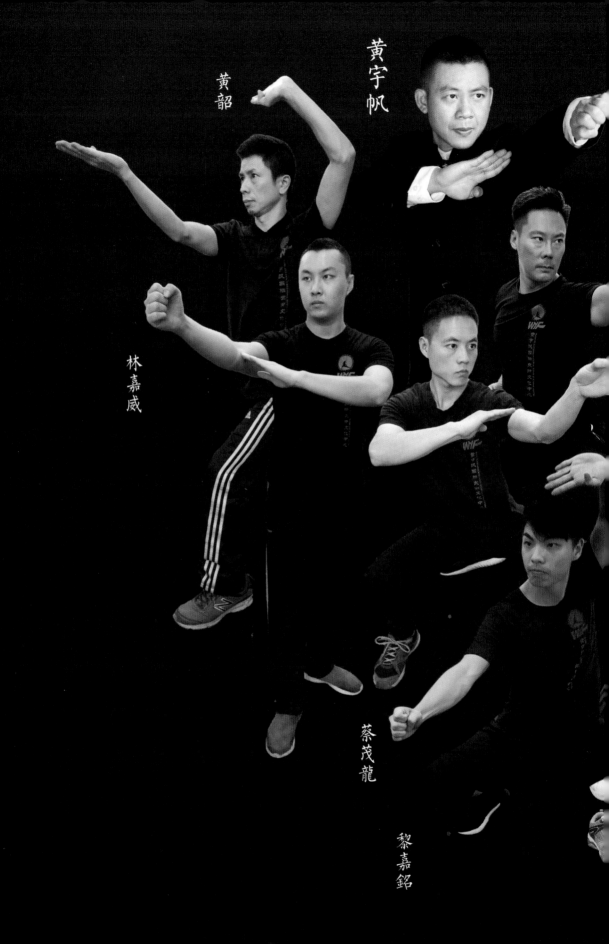

黄宇帆

黄韶

林嘉威

蔡茂龍

黎嘉銘

蔡李佛

黃宇帆國際武術文化中心

蔡李佛技擊法演示團隊

Ricky

甘漢忠

鄧鑫錚

蔡李佛技擊法

CHOY LI FUT FIGHTING TECHNIQUES

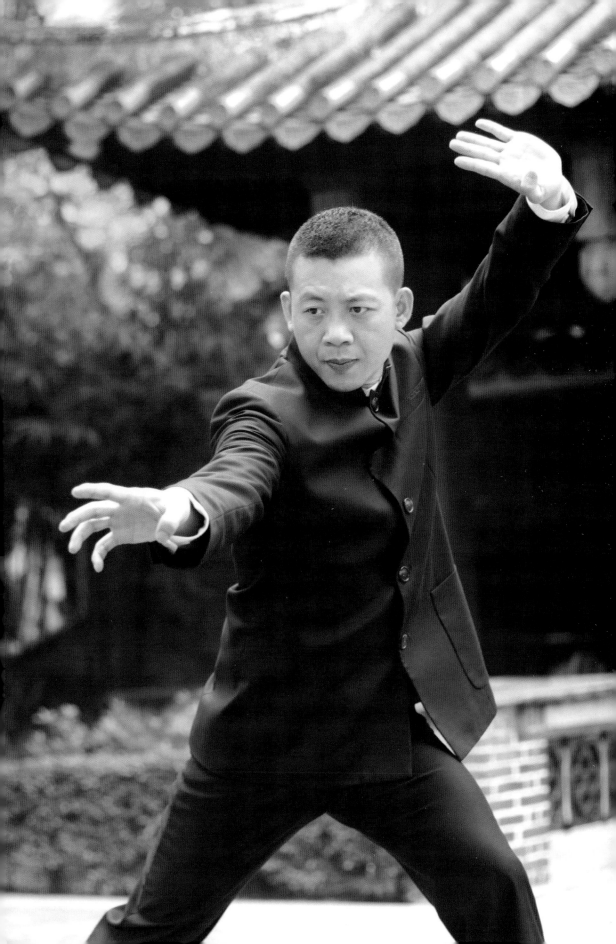

徒手

第一招
——
第十六招

UNARMED COMBAT
FIRST——SIXTEENTH

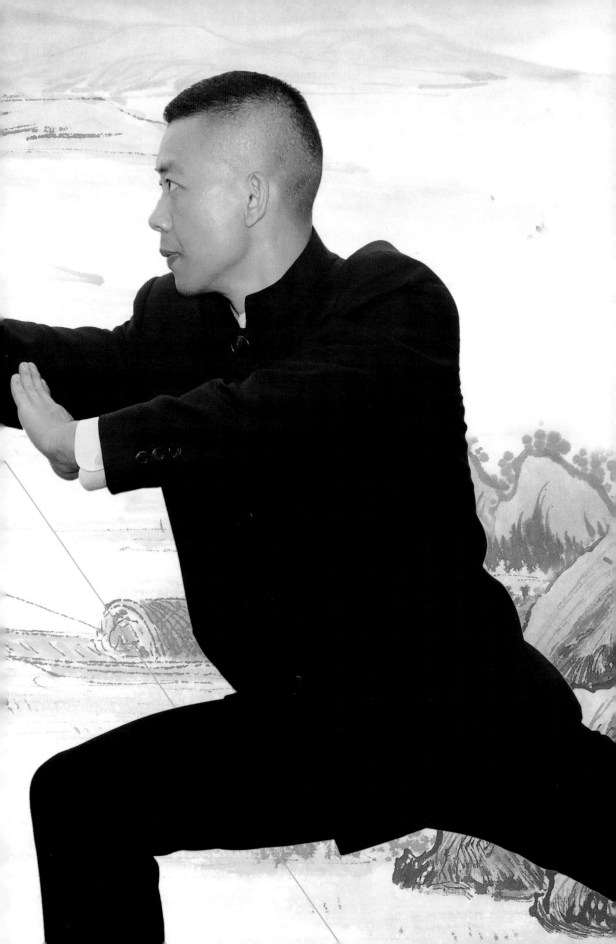

偷馬雙沉橋
轉身掛搥

Downward bridge hands with back cross stance
and back fist with turn

25

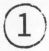 **偷馬雙沉橋**

Downward bridge hands with back cross stance

動作要領： 預備式(如圖1)，左腳向後偷步為右纏絲馬，雙掌交叉於頭上方，掌心
向外(如圖2)，由上往下雙沉橋，手掌與己耳同高，目視後方(如圖3)。

要　　求： 勁達指尖

Movement:
Ready position. (Fig.1) Move left foot to the back to form cross stance. Cross both palms above my side's head and then separate to two sides. (Fig.2)Palms are as high as my side's ears. Eyes are looking attentively at the back. (Fig.3)

Requirement:
Power is reached finger tips

圖1　　　　　　　　圖2　　　　　　　　　　圖3

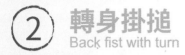

② 轉身掛搥
Back fist with turn

動作要領： 接上一動作，向左轉身進左子午馬，左拳由上往下掛搥，左拳與己
額同高，目視左拳方向(如圖4)。

要 求： 掄臂有力

Movement:
Continue with previous action. Turn the body to the left to form left straight
stance. Rotate left fist from top to bottom to form back fist. Left fist is as high as
my side's forehead. Eyes are looking attentively at the direction of left fist. (Fig.4)
Requirement:
Rotate arm forcefully

圖 4

應用

當敵方從後面拉我方肩膀 (如圖5)，我方即偷馬卸其拉力，同時交叉手於頭上(如圖6)，以防敵方攻擊我方頭頸部位，用雙沉橋化解敵方抓住我方的手，同時攻擊敵方臉部(如圖7)，當敵方閃避或截擋我方攻擊，我方再轉身掛搥追擊敵方頭部(如圖8)。

要求

變招要快

Application:

When opponent pulls my side's shoulder at back, (Fig.5) my side perform back cross stance to shift the pulling force. At the same time, my side cross hands above head, (Fig.6) to prevent opponent to attack my side's head/neck. Then, my side perform downward bridge hands to overcome opponent's hand which is grabbing my side's shoulder, and to attack opponent's face simultaneously. (Fig.7) When opponent dodges or blocks my side's offense, my side turn around and perform back fist immediately to strike the opponent's head. (Fig.8)

Requirement:

Change actions rapidly

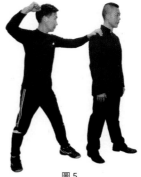

圖 5

圖 6

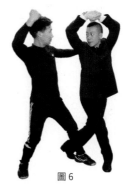

圖 7

圖 8

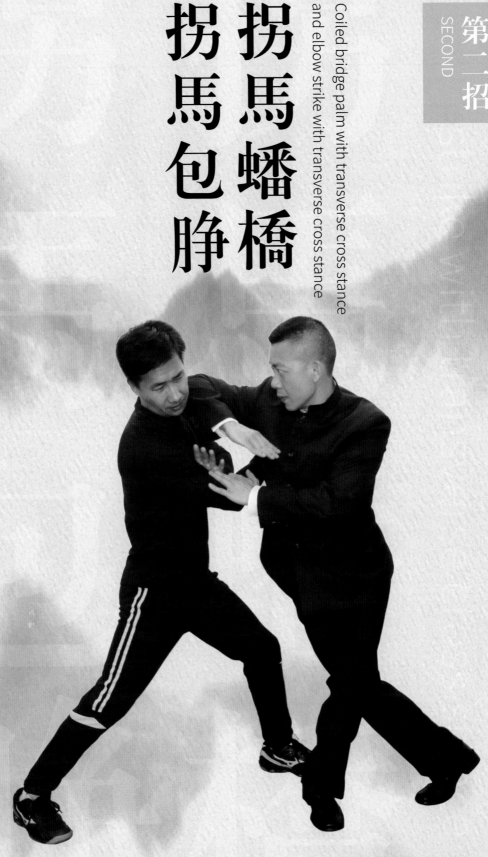

第二招
SECOND

拐馬蟠橋
拐馬包睜

Coiled bridge palm with transverse cross stance
and elbow strike with transverse cross stance

29

 拐馬蟠橋
Coiled bridge palm with transverse cross stance

動作要領: 預備式(如圖1)，拐右馬左蟠橋，收右拳於腰旁，目視左掌方向(如圖2)
要　求: 拐馬和蟠橋同時

Movement:
Ready position. (Fig.1) Perform coiled bridge palm with right transverse cross stance. At the same time, place right fist next to waist. Eyes are looking attentively at the direction of left palm. (Fig.2)
Requirement:
Perform transverse cross stance and coiled bridge palm simultaneously

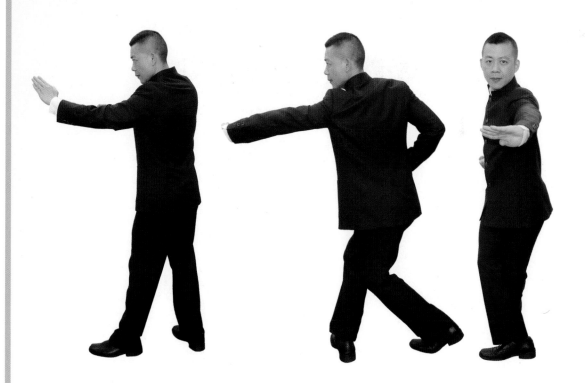

圖1　　　　　　　　　　圖 2-1　　　圖 2-2

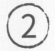

② 拐馬包睜
Elbow strike with transverse cross stance

動作要領： 接上一動作，拐左馬，同時右睜由右向左打出，右前臂與左掌相
撞，目視右睜方向(如圖 3)。

要 求： 力達手睜

Movement:

Continue with previous action. Perform left transverse cross stance. At the same time, strike right elbow from right to left so that right forearm is being collided with left palm. Eyes are looking attentively at the direction of right elbow. (Fig.3)

Requirement:

Power is reached elbow

圖 3

應用

預備式 (如圖 4)，敵方主動用右拳向我方頭部攻擊，我方即用拐馬蟠橋，右手拿住敵方手腕，左手蟠橋伏住敵方手睜或肩膀(如圖 5)，在敵方抗力或退縮時，我方即向前拐馬包睜，攻擊敵方頭部(如圖 6)。

要求

變招要快

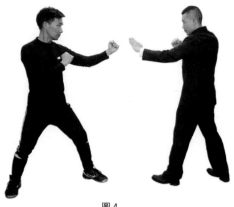

圖 4

Application:

Ready position. (Fig.4) Opponent attacks my side's head with right fist actively. My side catch opponent's wrist with right hand, and cover opponent's upper arm or shoulder with left hand. (Fig.5) If opponent resists or retreats, my side perform elbow strike with transverse cross stance to hit opponent's head. (Fig.6)

Requirement:

Change actions rapidly

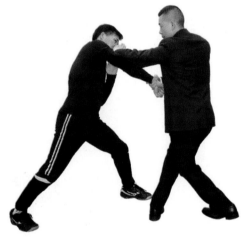

圖 5

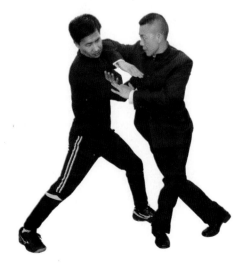

圖 6

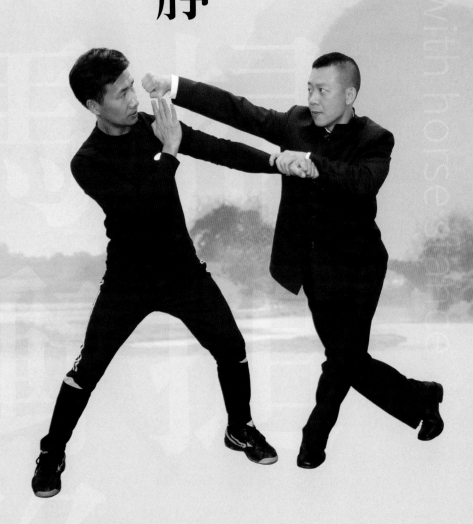

扭馬掃搥
四平馬衝靜

Sweeping fist with cross stance and
punching elbow with horse stance

第三招
THIRD

 扭馬掃搥
Sweeping fist with cross stance

動作要領： 預備式（如圖 1），扭左馬，同時左手護頭，右拳由右向左擺臂掃搥，右
拳與己頭部同高，目視右拳方向（如圖 2）。

要　　求： 擺臂有力

Movement:
Ready position. (Fig.1) Perform left cross stance. At the same time, place left hand above forehead for protection. Swing right fist from right to left to form sweeping fist. The right fist is as high as my side's head. Eyes are looking attentively at the direction of right fist. (Fig.2)

Requirement:
Swing arm forcefully

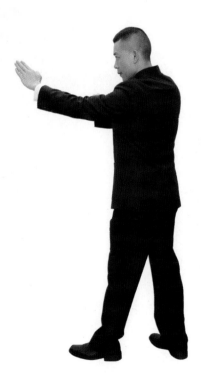

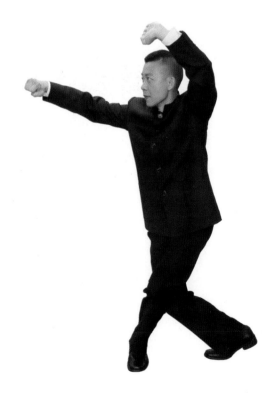

圖 1　　　　　　　　　　　　　　　　圖 2

 ## 四平馬衝睜
Punching elbow with horse stance

動作要領： 接上一動作，上右四平馬，雙睜對拉向右前方衝出，雙拳相對，雙
手睜與肩同高，目視右睜方向(如圖 3)。

要　　求： 力達睜尖

Movement:

Continue with previous action. Move forward with right horse stance. Punch out both elbows in contrary directions. Both fists are face to face and both elbows are horizontal to shoulders. Eyes are looking attentively at the direction of right elbow. (Fig.3)

Requirement:

Power is reached the tip of elbows

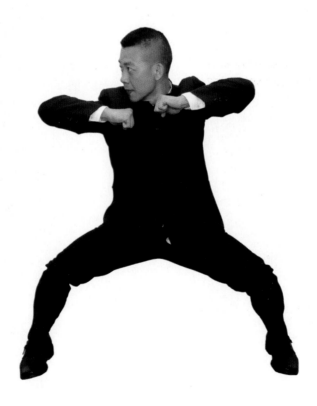

圖 3

應用

預備式(如圖4)，敵方主動用左拳向我方頭部攻擊，我方即左手拿住敵方手腕，扭左馬掃右搥，攻擊敵方頭部(如圖5)，當敵方用左臂上抬以圖阻止我方攻擊時，再上四平馬衝胗撞向敵方肋部(如圖6)。

要求

變招要快

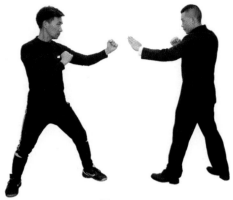

圖 4

Application:

Ready position. (Fig.4) Opponent attacks my side's head with left fist actively. My side catch opponent's wrist with left hand immediately and then perform right sweeping fist with left cross stance to strike opponent's head. (Fig.5) When opponent elevates left arm to block my side's offense, my side perform punching elbow with horse stance to hit opponent's ribs. (Fig.6)

Requirement:

Change actions rapidly

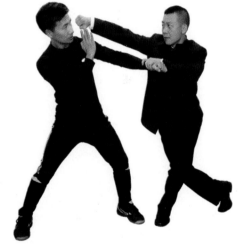

圖 5

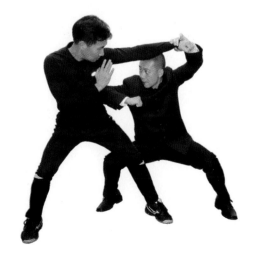

圖 6

扭馬千字
四平馬標撞

Downward side strike with cross stance and
upward side strike with horse stance

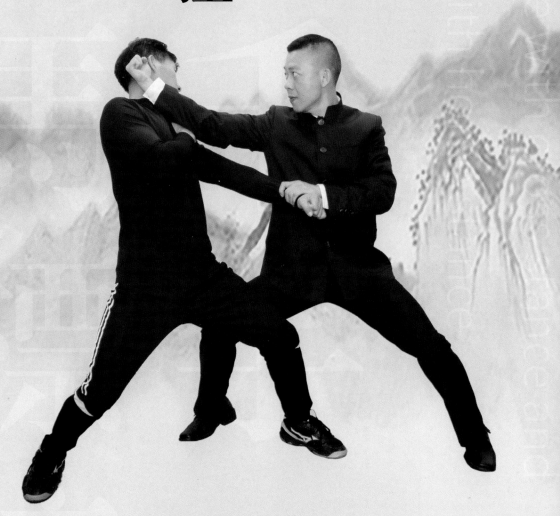

扭馬千字
Downward side strike with cross stance

動作要領： 預備式(如圖1)，扭左馬，同時左手護頭，右拳拉在身後，由右前上方向左前下方掄臂，拳心向上，右拳與己腰高，目視前方(如圖2)。

要　　求： 掄臂有力

Movement:

Ready position. (Fig.1) Move forward with left cross stance. At the same time, place left hand above forehead for protection. Right fist is at the back. Then, rotate right fist from top to bottom and stop at left-bottom position. Fist heart is facing upward. Right fist is as high as my side's waist. Eyes are looking attentively at the front. (Fig.2)

Requirement:

Rotate arm forcefully

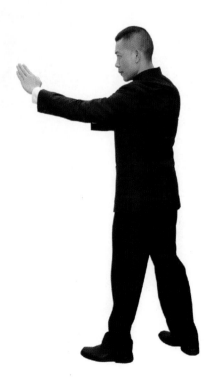

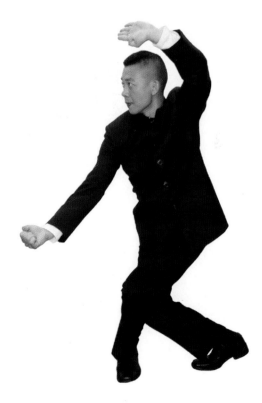

圖 1　　　　　　　　　　　　　　　　　　　　圖 2

② 四平馬標撞
Upward side strike with horse stance

動作要領： 接上一動作，上右四平馬，右拳由左向右上方標撞，拳心向上，右
拳與己眼同高，左掌護睜，目視右拳方向（如圖 3）。

要　　求： 以腰發勁

Movement:
Continue with previous action. Move forward with right horse stance. Swing
right fist to top-right position. Fist heart is facing upward. Right fist is as high as
my side's eyes. Place left palm next to right elbow for protection. Eyes are look-
ing attentively at the direction of right fist. (Fig.3)

Requirement:
Induce power from waist

圖 3

應用

預備式(如圖4)，敵方主動進馬
向我方頭部左直拳，我方左手
即拿敵方手腕，扭馬用千字手
攻擊敵方左肘關節(如圖5)，再
上四平馬標撞，攻擊敵方頭部
(如圖6)。

要求

變招要快

Application:
Ready position. (Fig.4) Opponent attacks my side's head with left straight fist actively. My side catch opponent's wrist with left hand and perform downward side strike with cross stance to hit opponent's left elbow joint. (Fig.5) Then, move forward with horse stance and perform upward side strike with horse stance to hit opponent's head. (Fig.6)

Requirement:
Change actions rapidly

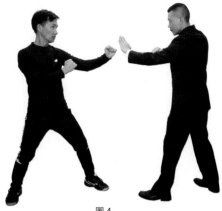

圖 4

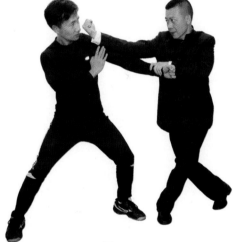

圖 5

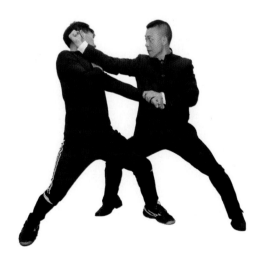

圖 6

四平馬掛搥
吊馬蟠橋
四平馬頂掌

Back fist with horse stance
coiled bridge palm with hanging stance
and withstanding palm with horse stance

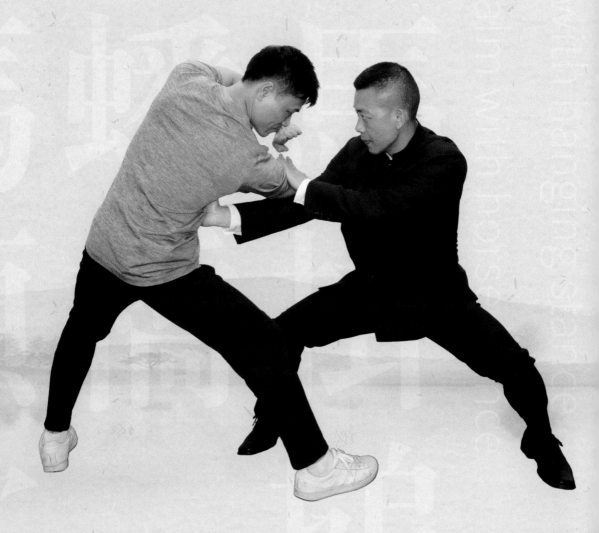

 四平馬掛搥
Back fist with horse stance

動作要領： 預備式(如圖1)，進右四平馬，同時右拳向前方掄臂掛搥，右拳與己
額頭同高，左掌護睜，目視右拳方向(如圖2)。

要　　求： 掄臂有力

Movement:
Ready position. (Fig.1) Move forward with right horse stance. At the same time,
rotate right fist to the front to perform back fist. Right fist is as high as my side's
forehead. Place left palm next to right elbow for protection. Eyes are looking
attentively at the direction of right fist. (Fig.2)

Requirement:
Rotate arm forcefully

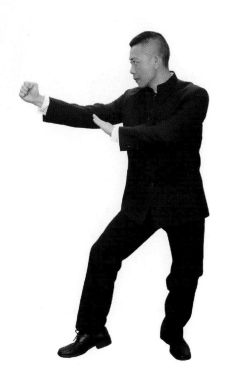

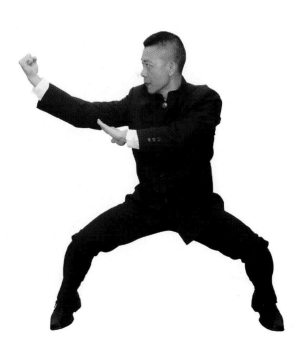

圖1 圖2

② 吊馬蟠橋
Coiled bridge palm with hanging stance

動作要領： 接上一動作，褪左腳吊右馬，左掌向前蟠橋，右拳收於腰旁，目視
左掌方向（如圖 3）。

要　　求： 褪馬要快

Movement:
Continue with previous action. Move left foot to the back to form right hanging
stance. Coil left palm to the front. Place right fist next to waist. Eyes are looking
attentively at the direction of left palm. (Fig.3)
Requirement:
Move back rapidly

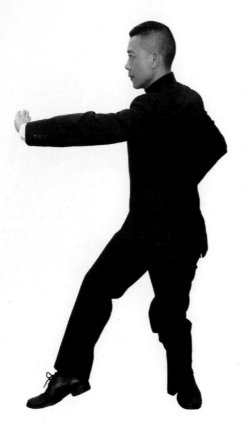

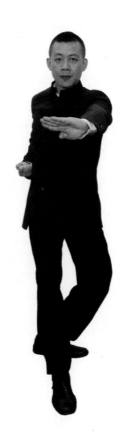

圖 3-1 圖 3-2

 四平馬頂掌
Withstanding palm with horse stance

動作要領： 接上一動作，進右四平馬，同時右掌從腰向前頂掌，左掌護胪，目
視右掌方向（如圖4）。

要　　求： 勁達掌根

Movement:
Continue with previous action. Move forward with right horse stance. At the
same time, push right palm to the front from waist. Place left palm next to right
elbow for protection. Eyes are looking attentively at the direction of right palm. (Fig.4)

Requirement:
Power is reached right palm

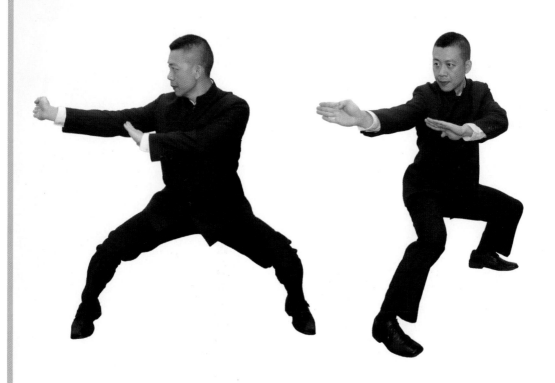

圖 4-1 圖 4-2

應用

預備式(如圖5)，我方主動進右四平馬向敵方頭部掛搥，敵方用右手格擋(如圖6)，我方即用吊馬蟠橋(如圖7)，將敵方向前的擋勢卸向右邊，再進四平馬頂掌，攻擊敵方中線(如圖8)。

要求

變招要快

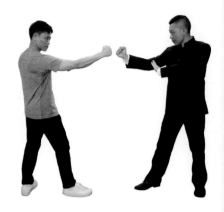

圖 5

Application:

Ready position. (Fig.5) My side move forward with right horse stance and perform back fist to strike opponent's head actively. Opponent blocks with right hand. (Fig.6) My side perform coiled bridge palm, (Fig.7) to shift opponent's onward defense to the right. Then, my side perform withstanding palm with horse stance to hit opponent's center line. (Fig.8)

Requirement:

Change actions rapidly

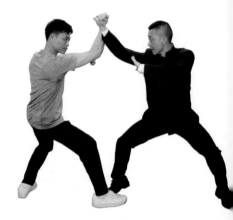

圖 6

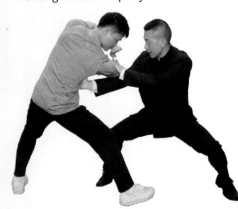

圖 8

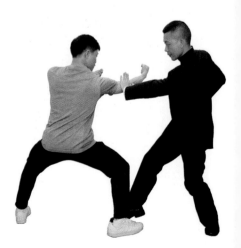

圖 7

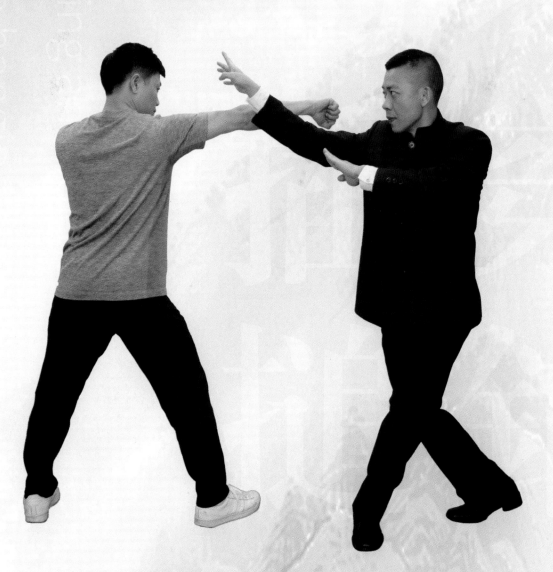

第六招
SIXTH

連環穿錨
吊馬插搥

Consecutive piercing anchor hand and
knuckle strike with hanging stance

 連環穿錨
Consecutive piercing anchor hand

動作要領： 預備式(如圖1)，偷右腳在後成左纏絲馬，同時右手向前穿錨，左掌護睜(如圖2)，然後再偷左腳在後吊右馬，同時左手向前穿錨，右掌護睜(如圖3)，穿錨手與己口鼻同高，目視穿錨手方向。

要　　求： 穿錨手手指要鬆

Movement:
Ready position. (Fig.1) Move right foot to the back to form cross stance. At the same time, pierce right hand to the front to form piercing anchor hand. Place left palm next to right elbow for protection. (Fig.2) Then, move left foot to the back to form right hanging stance. Pierce left hand to the front to form piercing anchor hand. Place right palm next to left elbow for protection. (Fig.3) Piercing anchor hand is as high as my side's mouth/nose. Eyes are looking attentively at the direction of piercing anchor hand.

Requirement:
Relax fingers for piercing anchor hand

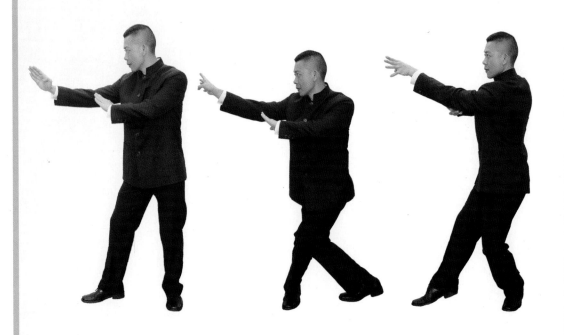

圖1 圖2 圖3

 吊馬插搥
Knuckle strike with hanging stance

動作要領： 接上一動作，吊右馬，向前右插搥，左掌護胏，插搥與己腰同高，目
視前方(如圖4)。

要　　求： 勁達搥尖

Movement:
Continue with previous action. Perform right knuckle strike with right hanging
stance. Place left palm next to right elbow for protection. Right hand is as high
as my side's waist. Eyes are looking attentively at the front. (Fig.4)

Requirement:
Power is reached the tip of bended fingers

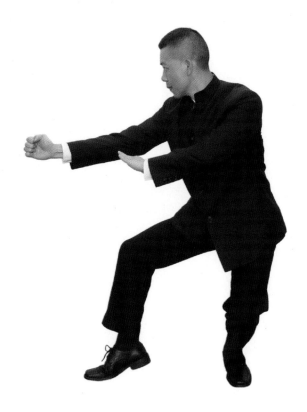

圖 4

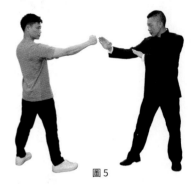

圖 5

應用

預備式(如圖 5)，敵方主動用右拳向我方頭部攻擊，我方即偷馬右穿錨，穿接敵方右臂(如圖 6)，當敵方快速用左拳追擊我方頭部時，我方再偷馬左穿錨，穿接敵方左臂(如圖 7)，此時敵方強勢已過，我方即吊右馬插搥，攻擊敵方腰腹部(如圖 8)

要求

變招要快

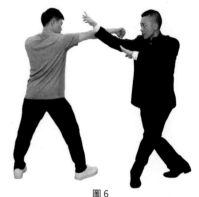

圖 6

Application:

Ready position. (Fig.5) Opponent attacks my side's head with right fist actively. My side move back with cross stance and perform piercing anchor hand to hold opponent's right arm. (Fig.6) When the opponent counterattack my side with left fist rapidly, my side move back with hanging horse and perform piercing anchor hand again to hold opponent's left arm. (Fig.7) At that time, opponent's offense is weakened. My side then perform knuckle strike to attack opponent's abdomen/waist. (Fig.8)

Requirement:

Change actions rapidly

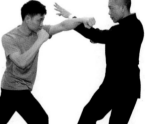
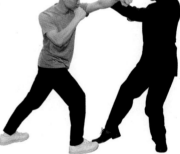

圖 7

圖 8

吊馬蟠橋
吊馬劈搥
提腿搶眼搥

Coiled bridge palm with hanging stance
splitting fist with hanging stance and
eye knuckle strike with elevating leg

吊馬蟠橋
Coiled bridge palm with hanging stance

動作要領： 預備式(如圖1)，吊右馬左手向前蟠橋，右拳在身後，左掌與己心同
高，目視左手方向(如圖2)。

要　　求： 雙手對拉有力

Movement:
Ready position. (Fig.1) Coil left palm to the front with right hanging stance. Right fist is at the back. Left palm is as high as my side's chest. Eyes are looking attentively at left hand side. (Fig.2)

Requirement:
Stretch hands forcefully

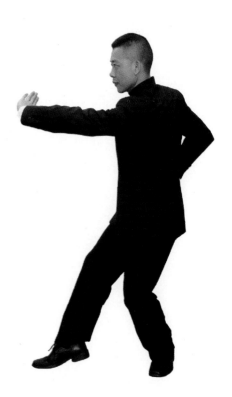

圖 1　　　　　　　　　　　　　　　　圖 2

 吊馬劈搥
Splitting fist with hanging stance

動作要領: 接上一動作，吊右馬，右拳由上往下向前掄臂劈搥，左掌護脏，右
拳與己心同高，目視前方(如圖 3)。

要　　求: 掄臂有力

Movement:
Continue with previous action. Perform right hanging stance. Rotate right arm
from top to bottom to perform splitting fist. Place left palm next to right elbow
for protection. Right fist is as high as my side's chest. Eyes are looking attentive-
ly at the front. (Fig.3)

Requirement:
Rotate arm forcefully

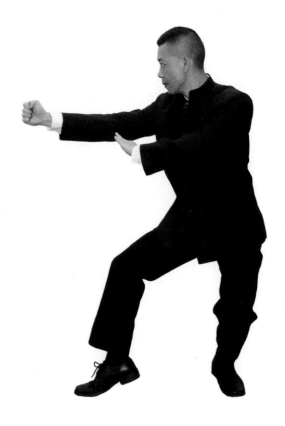

圖 3

 提腿搶眼搥
Eye knuckle strike with elevating leg

動作要領： 接上一動作，右腳踏實提左腿左搶眼搥，右掌護肘，左腳腳尖向
上，左搥與己眼同高，目視前方(如圖4)。

要　　求： 插搥和提腿同時

Movement:
Continue with previous action. When right foot is on the ground, elevate left leg and perform left eye knuckle strike. Place right palm next to left elbow for protection. The tip of left foot is facing upward. Left hand is as high as my side's eyes. Eyes are looking attentively at the front. (Fig.4)

Requirement:
Perform eye knuckle strike and elevate leg simultaneously

圖4

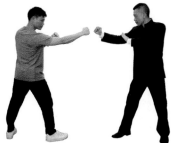

圖 5

應用

預備式(如圖 5)，敵方主動用右拳攻擊我方頭部(如圖 6)，我方左蟠橋截住敵方左手 (如圖 7)，然後向敵方頭部右劈搥，若被敵方左手格擋，我方再提左膝撞敵方心口，同時向敵方眼部左搶眼搥(如圖 8)。

要求

變招要快

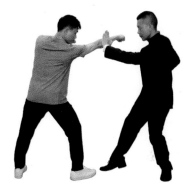

圖 6

Application:
Ready position. (Fig.5) Opponent attacks my side's head with right fist actively, (Fig.6) my side perform left coiled bridge palm to intercept opponent's left hand. (Fig.7) Then, my side perform right splitting fist to strike opponent's head. If opponents blocks the offense with left hand, my side elevate left leg and hit opponent's chest with knee. At the same time, perform left eye knuckle strike towards opponent's eye. (Fig.8)
Requirement:
Change actions rapidly

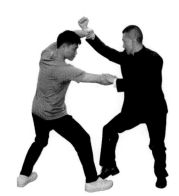

圖 7

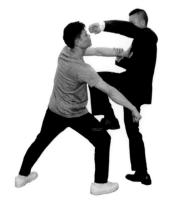

圖 8

橫馬捆橋
橫馬穿錨
橫馬撐掌

Downward intercepting bridge palm with transverse straight stance

piercing anchor hand with transverse straight stance and

level palm strike with transverse straight stance

　横馬捆橋
Downward intercepting bridge palm with transverse straight stance

動作要領： 預備式(如圖1)，左腳向左移動開左橫子午馬，同時右橋手由右向左
　　　　　　捆橋，指尖向下，右睜稍低於肩，左掌護睜，目視捆橋方向(如圖2)。

要　　求： 以腰發勁

Movement:

Ready position. (Fig.1) Move left foot to the left to form left transverse straight stance. At the same time, move right bridge hand from right to left to form downward intercepting bridge palm. Finger tips are facing downward. Right elbow is slightly lower than shoulder. Place left palm next to right elbow for protection. Eyes are looking attentively at the direction of right palm. (Fig.2)

Requirement:

Induce power from waist

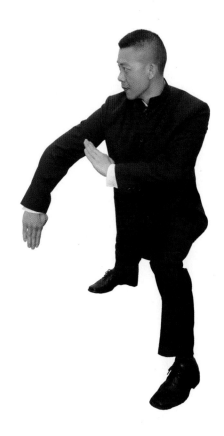

圖1　　　　　　　　　　　　　　　　圖2

 橫馬穿錨
Piercing anchor hand with transverse straight stance

動作要領: 接上一動作，左橫子午馬，右手向前穿錨，左掌護靜，穿錨手與鼻
同高，目視右手方向(如圖 3)。

要　　求: 穿錨手手指要鬆

Movement:
Continue with previous action. Pierce right hand from bottom to top to form piercing anchor hand. Place left palm next to right elbow for protection. The piercing anchor hand is as high as my side's nose. Eyes are looking attentively at right hand side. (Fig.3)

Requirement:
Relax fingers for piercing anchor hand

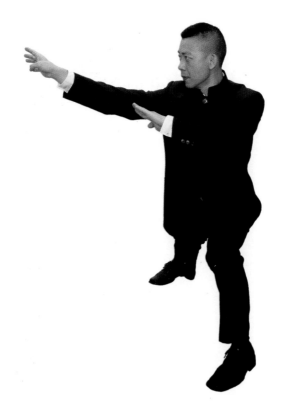

圖 3

 横馬撐掌
Level palm strike with transverse straight stance

動作要領： 接上一動作，由左橫子午馬轉右橫子午馬，左掌向前撐出，右拳收
於腰，左掌與己頸同高，目視左掌方向(如圖4)。

要　　求： 以腰發勁

Movement:
Continue with previous action. Change left transverse straight stance to right transverse straight stance. Strike left palm to the front. Place right fist next to waist. Left palm is as high as my side's neck. Eyes are looking at the direction of left palm. (Fig.4)

Requirement:
Induce power from waist

圖4

應用

當敵方用左手抓我方胸前衣服(如圖 5)，我方即用左手拿住敵方手腕，開橫左子午馬右捆橋截擊敵方肘關節(如圖 6)，如敵方卸我方捆橋勁時，我方即轉右穿錨追擊敵方面部 (如圖 7)，如敵方用右手格擋我方攻擊時(如圖 8)，我方再轉右橫子午馬撐掌，右手拉敵方右腕，左掌撐向敵方喉、面部(如圖 9)。

要求

變招要快

Application:

When opponent grabs my side's clothes with left hand actively, (Fig.5) my side catch opponent's left wrist with left hand immediately. Then, my side perform downward intercepting bridge palm with left transverse straight stance to intercept opponent's elbow joint. (Fig.6) If opponent relieves my side's offense, my side perform piercing anchor hand again to hit opponent's face. (Fig.7) When opponent blocks with right hand,(Fig.8) my side perform level palm with right transverse straight stance. Pull opponent's right wrist with right hand and strike on opponent's throat/face with left palm. (Fig.9)

Requirement:

Change actions rapidly

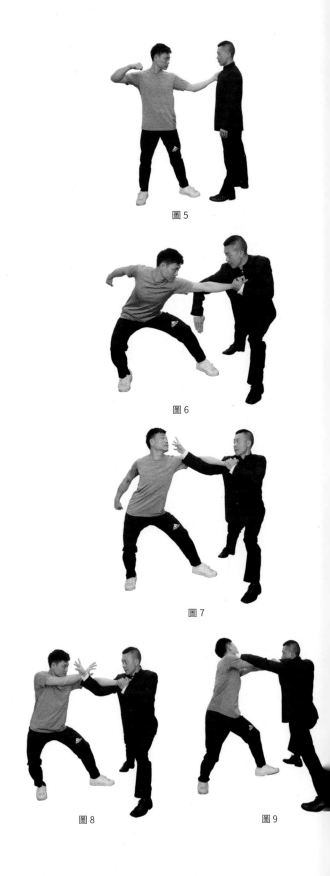

圖 5

圖 6

圖 7

圖 8

圖 9

側撐腿 掃眉腿

High sweeping leg and side propping leg

掃眉腿
High sweeping leg

動作要領： 預備式(如圖1)，右腳快速由左往右上方擺腿，腳背掃打右掌，腳與己臉同高，目視右腳方向(如圖2)。

要　　求： 擺腿有力

Movement:

Ready position. (Fig.1) Swing right leg from left to right-top position rapidly. Slap right palm with instep. Instep and right palm are as high as my side's face. Eyes are looking attentively at the direction of right foot. (Fig.2)

Requirement:

Swing leg forcefully

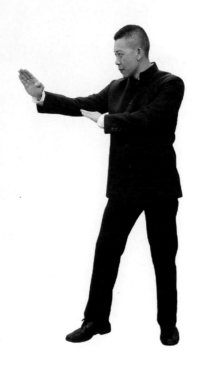

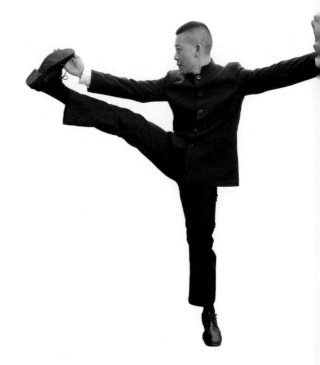

圖1 圖2

 側撐腿
Side propping leg

動作要領： 接上一動作，右腳着地，即向前側撐左腿，腳與己胸同高，目視撐
腿方向(如圖3)。

要　　求： 勁達腳外側

Movement:
Continue with previous action. When right leg is on the ground, elevate left leg
and prop to the front at the level of my side's chest. Eyes are looking attentively
at the direction of left leg. (Fig.3)

Requirement:
Power is reached outer side of leg

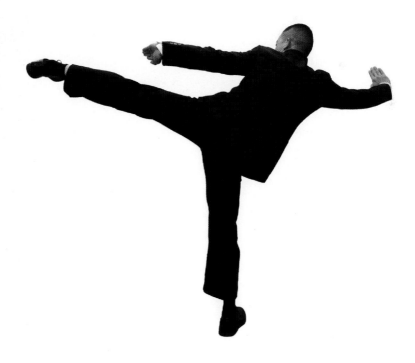

圖 3

應用

預備式（如圖4），當敵方右手持刀刺向我方胸腹時，我方快速向左移動，右腳向敵方手腕擺腿掃打（如圖5），當敵方器械被擊落或踢開時，我方右腳快速着地，再轉左側撐腿，撐敵方胸腹部位（如圖6）。

要求

變招要快

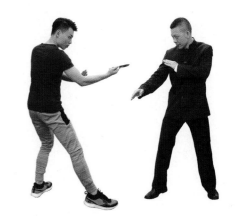

圖4

Application:

Ready position. (Fig.4) When opponent stabs my side's chest/abdomen with a dagger, my side move to the left rapidly. Then, swing right leg from left to right-top position to hit opponent's wrist with instep. (Fig.5) When the weapon is come off, my side perform side propping leg to hit opponent's chest/abdomen. (Fig.6)

Requirement:

Change actions rapidly

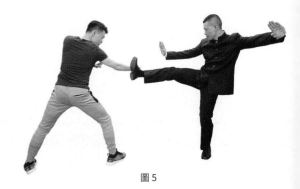

圖5

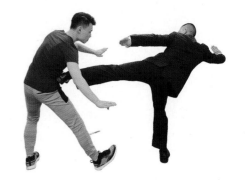

圖6

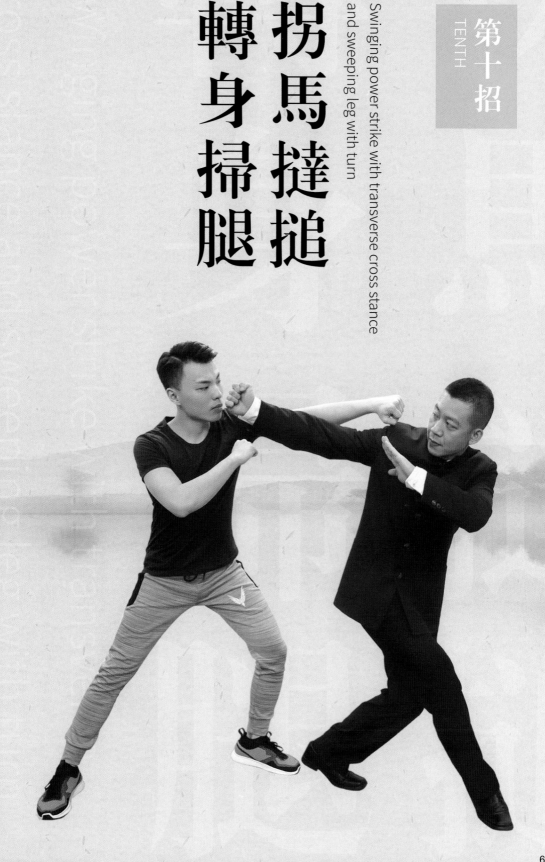

拐馬撻搥
轉身掃腿

Swinging power strike with transverse cross stance
and sweeping leg with turn

第十招
TENTH

 拐馬撻搥
Swinging power strike with transverse cross stance

動作要領： 預備式(如圖 1)，右腳向後拐馬，雙手運手回身右撻搥，左掌護胛，目
視右手方向(如圖 2)。

要　　求： 勁達右搥

Movement:
Ready position. (Fig.1) Move right foot to the back to form back transverse cross stance. Swing both hands when turning the body and finally right hand is at the back. Place left palm next to right elbow for protection. Eyes are looking attentively at right hand side. (Fig.2)

Requirement:
Power is reached right fist

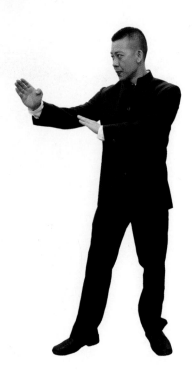

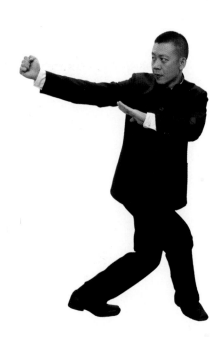

圖 1　　　　　　　　　　　　　　　　　　　　圖 2

② 轉身掃腿
Sweeping leg with turn

動作要領： 接上一動作，左腳為重心腳，轉身掃腿，目視右腿方向（如圖 3）。

要　　求： 快速轉身

Movement:

Continue with previous action. Treat left foot as center of gravity, turn round and sweep right foot. Eyes are looking attentively at the direction of right foot. (Fig.3)

Requirement:

Turn round rapidly

圖 3

應用

預備式(如圖4)，敵方主動用左拳向我方頭部攻擊，我方即右腳向後拐馬，同時向敵方頭部右撻搥(如圖5)，當敵方向後急閃時，我方再轉身向敵方下盤掃腿(如圖6)。

要求

變招要快

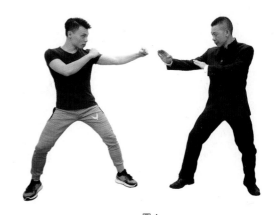

圖4

Application:

Ready position. (Fig.4) Opponent attacks my side's head with left fist actively, my side move right foot to the back to form transverse cross stance. At the same time, my side perform right swinging power strike to hit opponent's head. (Fig.5) When opponent steps back to evade, my side turn round and strike opponent's lower part of the body with leg. (Fig.6)

Requirement:

Change actions rapidly

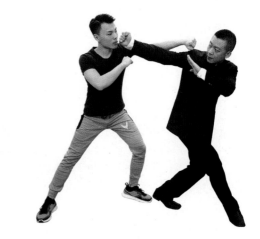

圖5

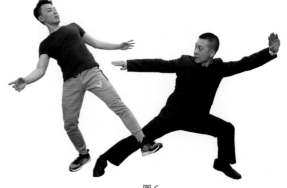

圖6

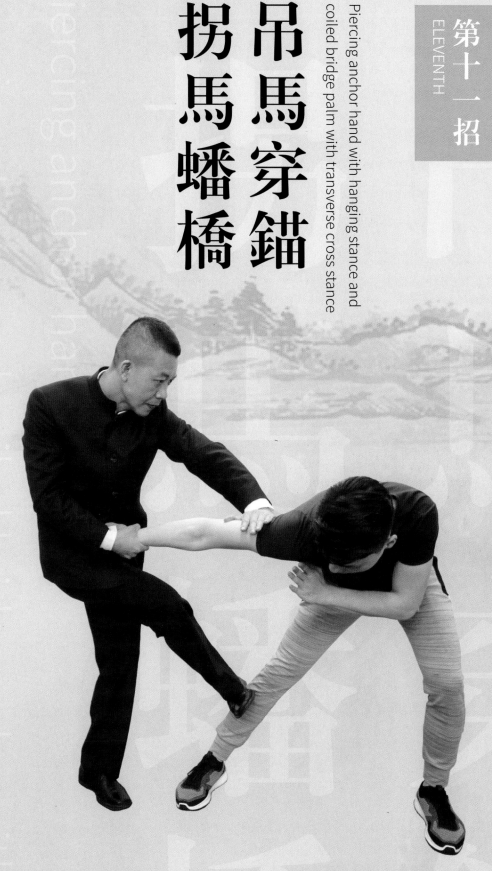

吊馬穿錨
拐馬蟠橋

Piercing anchor hand with hanging stance and coiled bridge palm with transverse cross stance

① **吊馬穿錨**
Piercing anchor hand with hanging stance

動作要領： 預備式(如圖 1)，吊左馬，左手向前方穿錨，右掌護睜，左手與己鼻
高，目視前方(如圖 2)。

要　　求： 穿錨手手指要鬆

Movement:
Ready position. (Fig.1) Perform left hanging stance. Pierce left hand to the front
to form piercing anchor hand. Place right palm next to left elbow for protection.
Left hand is as high my side's nose. Eyes are looking attentively at the front.
(Fig.2)

Requirement:
Relax fingers for piercing anchor hand

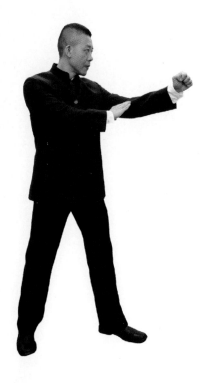

圖 1 圖 2

 拐馬蟠橋
Coiled bridge palm with transverse cross stance

動作要領： 接上一動作，右腳向前拐右馬，左手蟠橋，右拳收於腰，目視前方 (如圖 3)。

要　　求： 雙手對拉有力

Movement:
Continue with previous action. Move right foot to the front to form transverse cross stance. Coil left palm to the front. Place right fist next to waist. Eyes are looking attentively at the front. (Fig.3)

Requirement:
Stretch hands forcefully

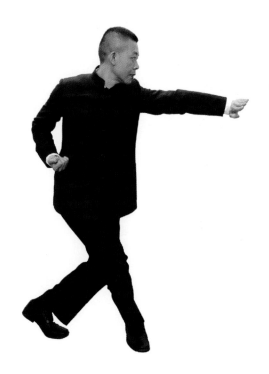

圖 3

應用

預備式(如圖4)，敵方向我方頭部右掃搥，我方可用左穿錨手截住敵方右掃拳(如圖5)，再用右手拿住敵方右腕，左手蟠橋反敵方肘關節，同時右腳踩敵方膝關節(如圖6)。

要求

變招要快

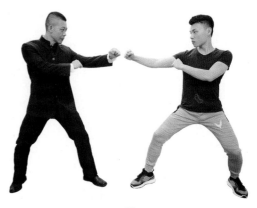

圖 4

Application:
Ready position. (Fig.4) Opponent attacks my side's head with right sweeping fist, my side intercept with left piercing anchor hand. (Fig.5) Then, my side grab opponent's right wrist with right hand and coil up left palm to twist opponent's elbow joint. At the same time, elevate right foot to step on opponent's knee joint. (Fig.6)

Requirement:
Change actions rapidly

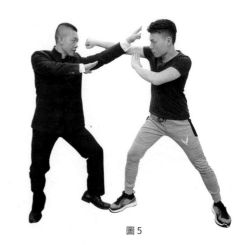

圖 5

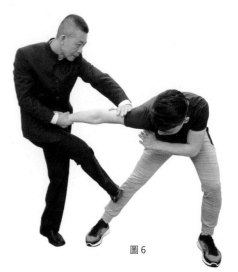

圖 6

子午馬掛搥
扭馬笈搥
子午馬撞搥

Back fist with straight stance
downward strike with cross stance and
small upward power strike with straight stance

① 子午馬掛搥
Back fist with straight stance

動作要領： 預備式(如圖1)，進右子午馬，右拳向前掄臂掛搥，左拳在身後斜下
方，右拳與己額同高，目視前方(如圖2)。

要　　求： 掄臂有力

Movement:
Ready position. (Fig.1) Move forward with right straight stance. At the same time,
rotate right arm to the front to perform back fist. Left fist is at the back. Right fist
is as high as my side's forehead. Eyes are looking attentively at the front. (Fig.2)

Requirement:
Rotate arm forcefully

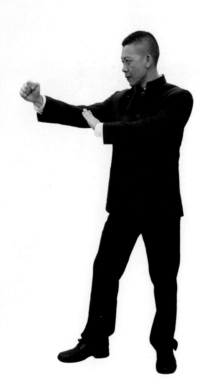

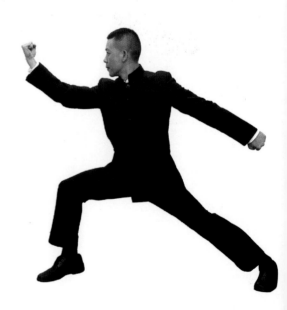

圖1　　　　　　　　　　　　　　　圖2

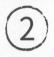

② 扭馬笈搥
Downward strike with cross stance

動作要領： 接上一動作，扭右馬，左拳向前掄臂笈搥，左拳與己額同高，拳心
　　　　　　向下，右拳在身後斜下方，目視前方（如圖3）。

要　　求： 掄臂有力

Movement:
Continue with previous action. Perform right cross stance. Rotate left arm to the
front to perform downward strike. Left fist is as high as my side's forehead and
facing downward. Right fist is at the back. Eyes are looking attentively at the
front. (Fig.3)

Requirement:
Rotate arm forcefully

圖3

③ 子午馬撞搥
Small upward power strike with straight stance

動作要領： 接上一動作，上左子午馬，左拳由上往後下方掄臂，右拳由下往上向前撞搥，右拳與己下巴同高，目視前方 (如圖4)。

要　　求： 掄臂有力

Movement:
Continue with previous action. Move forward with left straight stance. At the same time, punch right fist from bottom to top. Right fist is as high as my side's chin. Eyes are looking attentively at the front. (Fig. 4)

Requirement:
Rotate arm forcefully

圖4

應用

預備式(如圖 5)，我方主動用右掛搥向敵方頭部攻擊，敵方用右手截擋(如圖 6)，我方即向敵方頭部笈搥(如圖 7)，若被敵方阻擋，再上步向敵方下巴右撞搥(如圖 8)。

要求

變招要快

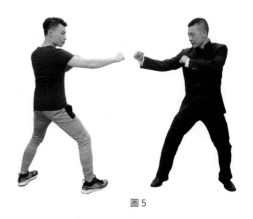

圖 5

Application:

Ready position. (Fig.5) My side attack opponent's head with right back fist actively. Opponent intercepts with right hand. (Fig.6) My side perform downward strike towards opponent's head. (Fig.7) If downward strike is blocked, my side move forward and perform right small upward power strike to hit opponent's chin. (Fig.8)

Requirement:

Change actions rapidly

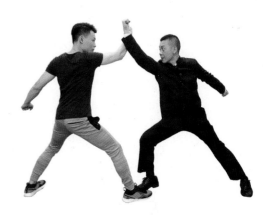

圖 6

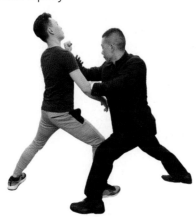

圖 8

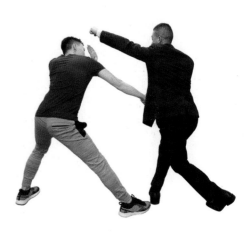

圖 7

醉步截橋鳳眼搥

Drunken step with intercepting bridge hand and eichhornia knuckle strike

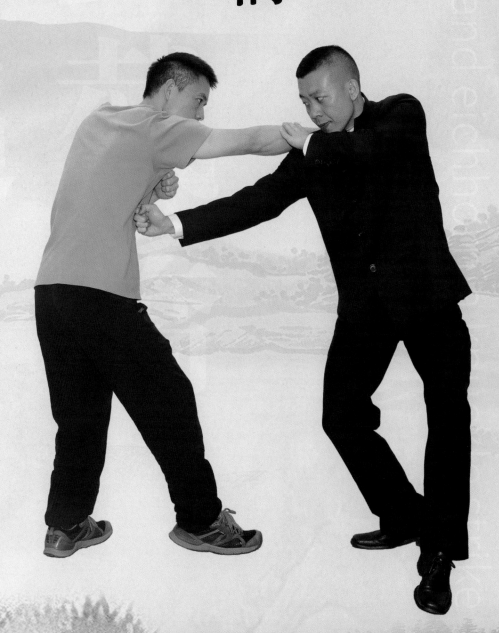

 醉步截橋鳳眼搥
Drunken step with intercepting bridge hand and eichhornia knuckle strike

動作要領： 預備式(如圖 1)，向左醉步拐右橫纏絲馬，
同時左截橋，右鳳眼搥後拉，目視左手
方向(如圖 2)，然後醉步偏馬插右鳳眼搥，
左手後拉，目視右搥方向(如圖 3)。

要　　求： 雙手對拉有力

Movement:
Ready position. (Fig.1) Move right foot to the left with right transverse cross stance in drunken step. At the same time, perform left intercepting bridge hand. Pull right hand to the back. Eyes are looking attentively at left hand side. (Fig.2) Then, perform right eichhornia knuckle strike with transverse hanging stance in drunken step. Pull left hand to the back. Eyes are looking attentively at right hand side. (Fig.3)

Requirement:
Stretch hands forcefully

圖 1

圖 2

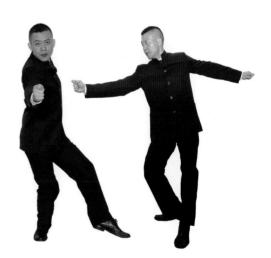

圖 3

應用

預備式(如圖4)，敵方向我方頭部右插搥，我方即向左醉步拐馬左截橋(如圖5)，截開敵方攻擊，然後快速偏右馬插右鳳眼搥，攻擊敵方肋部或腰部(如圖6)。

要求

變招要快

Application:

Ready position. (Fig.4) Opponent attacks my side's head with right knuckle strike. My side move to the left with cross stance in drunken step and perform left intercepting bridge hand, (Fig.5) to shift opponent's offense. Then my side perform right eichhornia knuckle strike with transverse hanging stance, to hit opponent's ribs or waist. (Fig.6)

Requirement:

Change actions rapidly

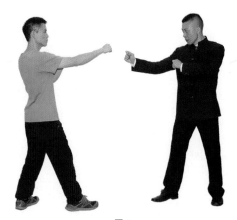

圖 4

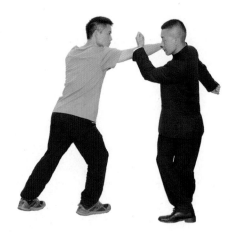

圖 5

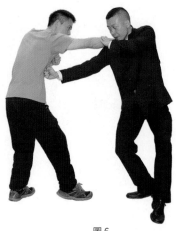

圖 6

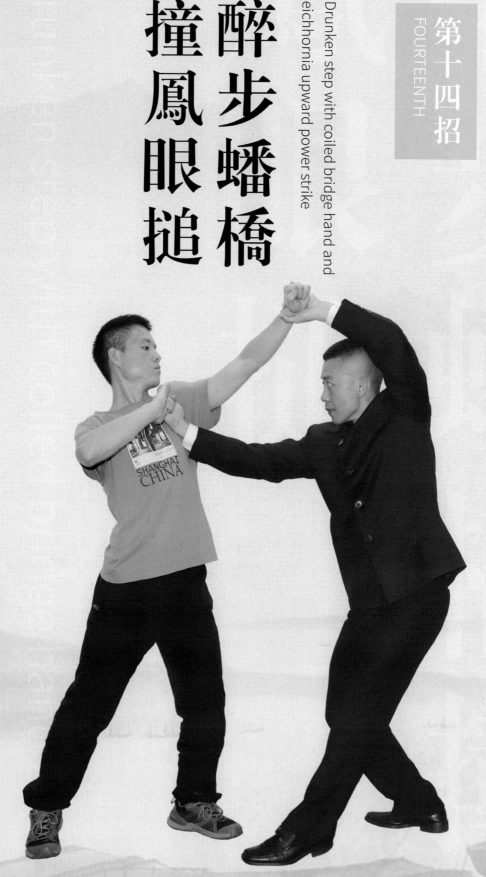

醉步蟠橋
撞鳳眼搥

Drunken step with coiled bridge hand and
eichhornia upward power strike

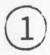

醉步蟠橋撞鳳眼搥
Drunken step with coiled bridge hand and eichhornia upward power strike

動作要領： 預備式(如圖1)，醉步偷左馬左蟠橋，右搥後拉(如圖2)，吊左馬右手由下往上撞鳳眼搥，右搥與己下巴同高，左搥護頭，目視前方(如圖3)。

要　　求： 雙手對拉有力

Movement:
Ready position. (Fig.1) Move left foot to the back and perform left coiled bridge hand. Pull right hand to the back. (Fig.2) Then, perform eichhornia upward power strike with left hanging stance. Right hand is as high as my side's chin. Place left hand above forehead for protection. Eyes are looking attentively at the front. (Fig.3)

Requirement:
Stretch hands forcefully

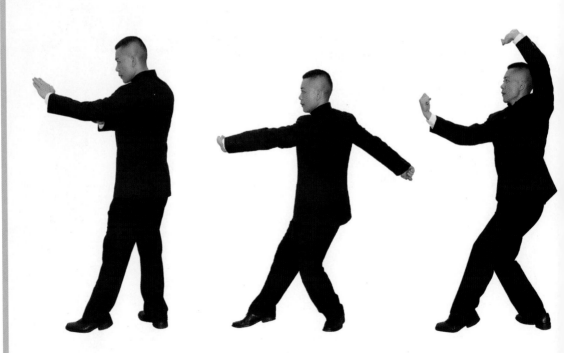

圖 1　　　　　　　圖 2　　　　　　　圖 3

應用

預備式(如圖4)，當敵方向我方頭部左插搥，我方即偷馬左蟠橋，蟠開敵方攻擊(如圖5)，敵方再出右插搥時，我方可吊左馬撞右鳳眼搥，攻擊敵方喉、下巴部位(如圖6)。

要求

變招要快

Application:

Ready position. (Fig.4) When opponent attacks my side's head with left knuckle strike, my side perform left coiled bridge hand with back cross stance, to shift opponent's offense. (Fig.5) When opponent performs right knuckle strike again, my side can perform eichhornia upward power strike with left hanging stance to hit opponent's throat/chin region. (Fig.6)

Requirement:

Change actions rapidly

圖 4

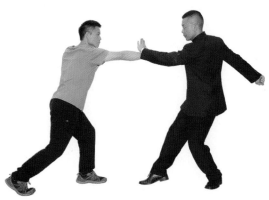

圖 5

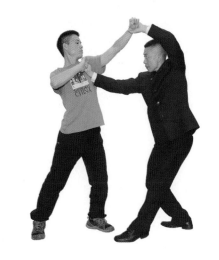

圖 6

虎爪 撐掌撩陰腳

Tiger claw
level palm strike and snap kick

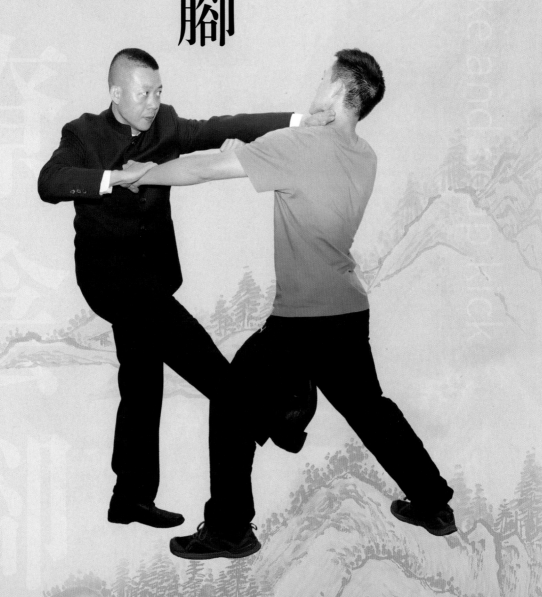

① 虎爪
Tiger claw

動作要領： 預備式(如圖1)，左蟠橋(如圖2)，進左子午馬，右手成虎爪向前上方撲出，
左掌護胜，虎爪與己面部同高，目視前方(如圖3)。

要　　求： 以腰發勁

Movement:

Ready position. (Fig.1) Perform left coiled bridge palm. (Fig.2) Move forward with left
straight stance. Change right hand to tiger claw form and pounce to the front. Place
left palm next to right elbow for protection. The tiger claw is as high as my side's
face. Eyes are looking attentively at the front. (Fig.3)

Requirement:

Induce power from waist

圖 1　　　　　　　　　　　　圖 2　　　　　　　　　　　　圖 3

 撐掌撩陰腳
Level palm strike and snap kick

動作要領： 接上一動作，左手向前撐掌，同時右撩陰腳，左掌與己喉同高，右掌向
後拉，右腳與己襠部同高，目視左手方向（如圖4）。

要　　求： 撐掌出腳同時

Movement:
Continue with previous action. Strike left palm to the front. At the same time, elevate right foot for kicking. Left palm is as high as my side's throat. Right palm is at the back. Right leg is as high as my side's lower part of the body. Eyes are looking attentively at left hand side. (Fig.4)

Requirement:
Perform level palm strike and snap kick simultaneously

圖4

應用

預備式（如圖5），敵方主動用右
拳向我方頭部攻擊，我方即用
左蟠橋蟠開敵方右拳（如圖6），
然後用虎爪撲擊敵方面部（如
圖7），如敵方用左手格擋我方
右手，我方即快速用右手拉開
敵方左手，向敵方喉部左撐
掌，同時右撩陰腳向敵方下盤
攻擊（如圖8）。

要求

變招要快

Application:
Ready position. (Fig.5) When
opponent attacks my side's
head with right fist actively,
my side perform left coiled
bridge palm to shift oppo-
nent's right fist. (Fig.6) Then my
side perform tiger claw to
pounce on opponent's face.
(Fig.7) If opponent blocks my
side's right hand with left
hand, my side grab oppo-
nent's left hand rapidly and
strike left palm on opponent's
throat. At the same time, ele-
vate right leg to strike oppo-
nent's lower part of the body.
(Fig.8)
Requirement:
Change actions rapidly

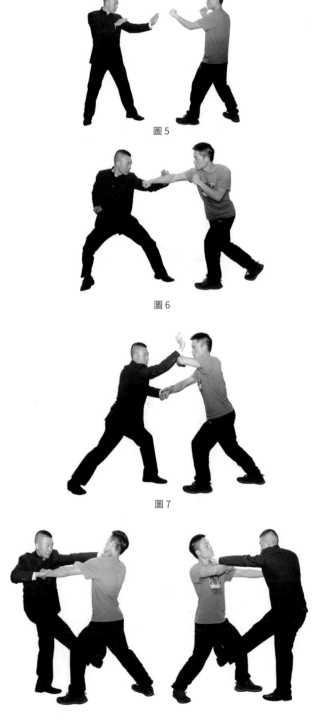

圖 5

圖 6

圖 7

圖 8

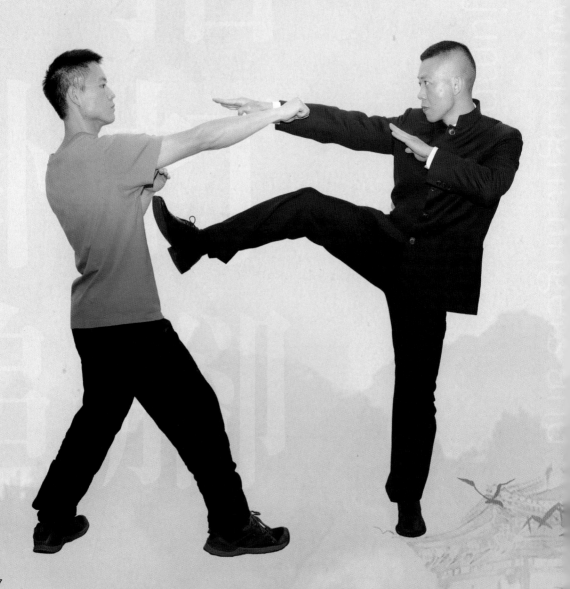

箭指打腳
跳步掛摳

Springing leg with tight fingers and
back fist with jump

箭指打腳
Springing leg with tight fingers

動作要領： 預備式(如圖1)，踢右腳，腳與己腰同高，同時右掌指向前方，右掌與己
眼同高，左掌護胤，目視前方(如圖2)。

要　　求： 手腳同時出擊

Movement:

Ready position. (Fig.1) Kick right foot to the level of my side's waist. At the same
time, point right palm to the front. Right palm is as high as my side's eyes. Place left
palm next to right elbow for protection. Eyes are looking attentively at the front. (Fig.2)

Requirement:

Perform actions simultaneously

圖 1

圖 2

② 跳步掛搥
Back fist with jump

動作要領： 接上一動作,右腳落地向前跳步(如圖3),進右子午馬掄臂右掛搥,左手
護睜,右拳與己額同高,目視前方(如圖4)。

要　　求： 跳步迅速

Movement:
Continue with previous action. Jump to the front when right foot is on the ground.
(Fig.3) Move forward with right straight stance and perform right back fist. Place left
palm next to elbow for protection. Right fist is as high as my side's forehead. Eyes
are looking attentively at the front. (Fig.4)

Requirement:
Jump rapidly

圖 3-1　　　　　　　　圖 3-2　　　　　　　　圖 3-3

圖 4

應用

預備式（如圖 5），當敵方向我方攻擊時，我方可用右箭指插向敵方的眼睛，從而阻止敵方的攻勢，同時用右腳攻擊敵方襠部（如圖 6），如果敵方向後退，我方可向前跳步追逼（如圖 7），同時用右掛搥攻擊敵方頭部（如圖 8）。

要求

變招要快

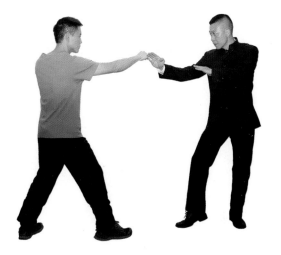

圖 5

Application:

Ready position. (Fig.5) When opponent attacks my side, my side point the tight fingers towards opponent's eyes so as to stop the offense. At the same time, my side strike opponent's lower part of the body with right foot. (Fig.6) If opponent steps back, my side keep chasing by jumping to the front. (Fig.7) At the same time, my side perform right back fist to strike opponent's head. (Fig.8)

Requirement:

Change actions rapidly

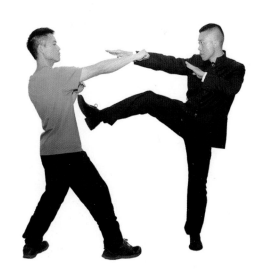

圖 6

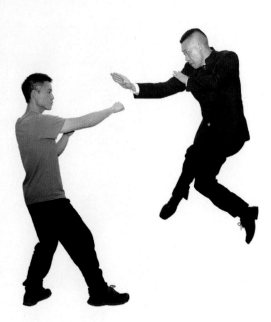

圖 7

圖 8

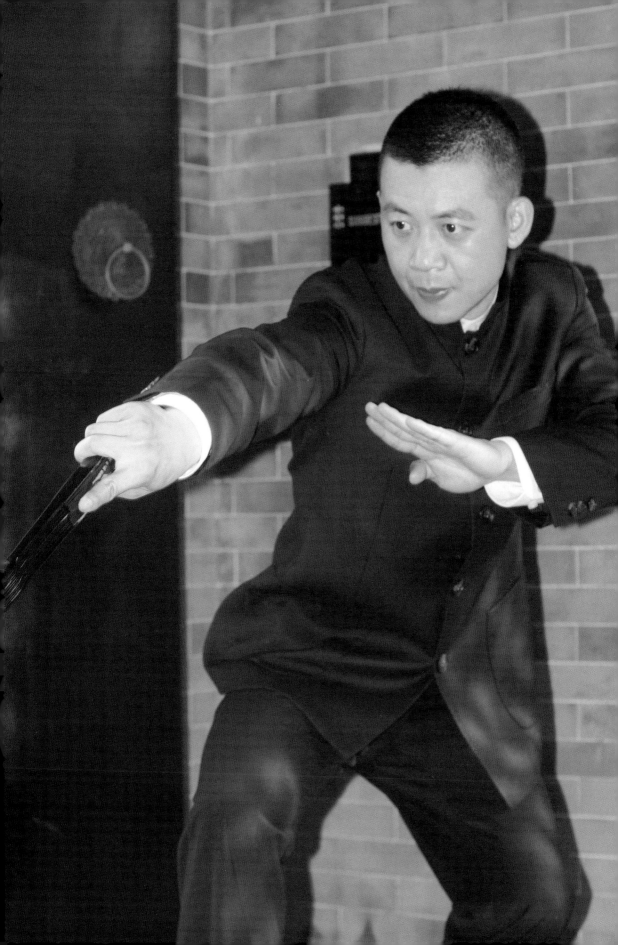

扇
第十七招
——
第二十招

FAN
SEVENTEENTH——
TWENTIETH

偏馬鳳眼搥
偏馬橫撞扇

Eichhornia knuckle strike with transverse hanging stance
and horizontal fan strike with transverse hanging stance

 偏馬鳳眼搥
Eichhornia knuckle strike with transverse hanging stance

動作要領： 預備式(如圖 1)，左腳向左移動偏左吊右馬，左手握鳳眼搥向左腳尖
方向插出，與己腰腹同高，右手握扇於身後，目視左手方向(如圖 2)。

要　　求： 勁達扇尖

Movement:

Ready position. (Fig.1) Move left foot to the left to form right hanging stance in left transverse orientation. Perform left eichhornia knuckle strike to the direction of tiptoe of left foot. Left hand is as high as my side's waist/abdomen. Right hand is holding the fan at the back. Eyes are looking attentively at left hand side. (Fig.2)

Requirement:

Power is reached the tip of fan

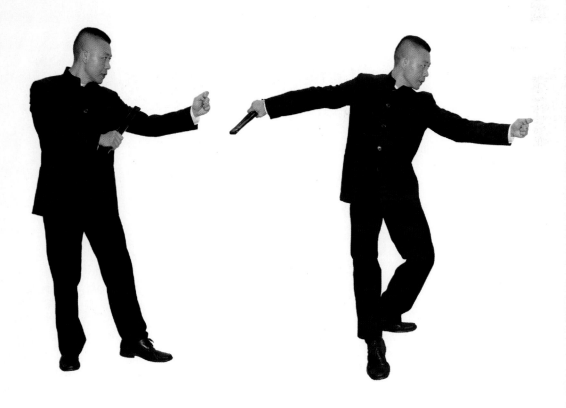

圖 1　　　　　　　　　　　　圖 2

 偏馬橫撞扇
Horizontal fan strike with transverse hanging stance

動作要領： 接上一個動作，右腳向右移動偏右吊左馬，右手握扇由右往左橫
插，扇與肋同高，左手拉於身後，目視右手方向（如圖 3）。

要　　求： 以腰發力

Movement:

Continue with previous action. Move right foot to the right to form left hanging
stance in right transverse orientation. Swing right hand which is holding the fan
from right to left horizontally. The fan is as high as my side's ribs. Pull left hand
to the back. Eyes are looking attentively at right hand side. (Fig.3)

Requirement:

Induce power from waist

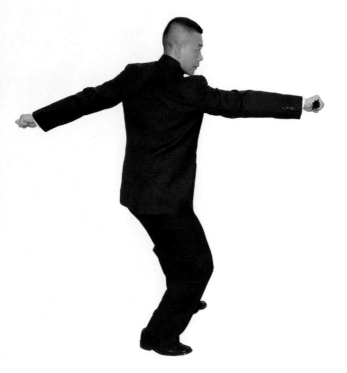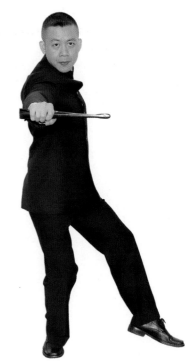

圖 3

應用

預備式(如圖 4)，當敵方用右拳向我方頭部攻擊時，我方即偏左馬向敵方腰腹部插鳳眼搥(如圖 5)，敵方閃避同時用左拳攻擊我方時，我方再向右橫偏右馬，右手握扇向敵方肋部橫撞(如圖 6)。

要求

變招要快

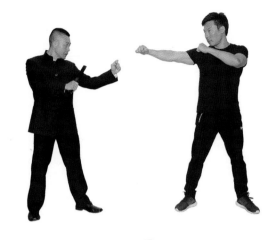

圖 4

Application:

Ready position. (Fig.4) When opponent attacks my side's head with right fist, my side perform eichhornia knuckle strike with right hanging stance in left transverse orientation to hit opponent's waist/abdomen. (Fig.5) Opponent evades and attacks my side with left fist at the same time. My side move to the right with left hanging stance in right transverse orientation, then perform horizontal fan strike to hit opponent's ribs. (Fig.6)

Requirement:

Change actions rapidly

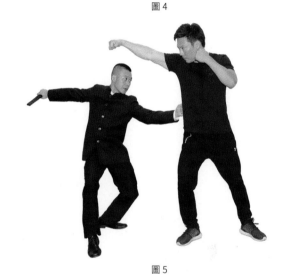

圖 5

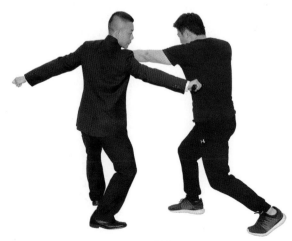

圖 6

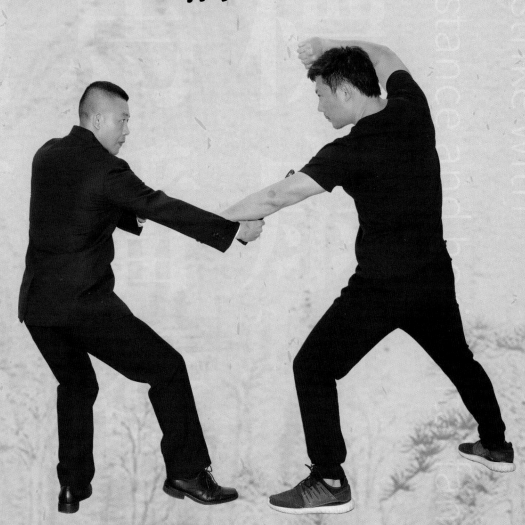

第十八招
EIGHTEENTH

吊馬標扇
子午馬蟠橋
偏馬拋打

Upward fan strike with hanging stance
coiled bridge palm with straight stance and
throwing strike with transverse hanging stance

 吊馬標扇
Upward fan strike with hanging stance

動作要領： 預備式（如圖 1），偷左腳吊右馬，右手握扇由下往上標撞，扇尖與己
喉同高，左掌護睜，目視前方（如圖 2）。

要　　求： 勁達扇尖

Movement:
Ready position. (Fig.1) Move left foot to the back to form right hanging stance.
Swing right hand which is holding the fan from bottom to top. Tip of fan is as
high as my side's throat. Place left palm next to right elbow for protection. Eyes
are looking attentively at the front. (Fig.2)

Requirement:
Power is reached the tip of fan

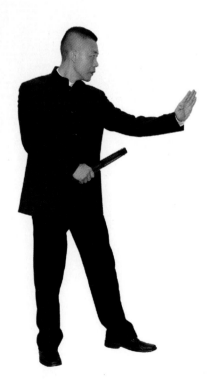

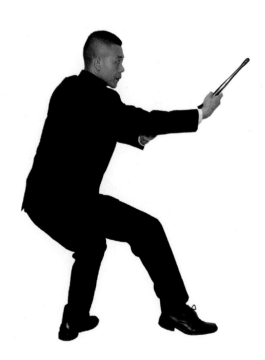

圖 1　　　　　　　　　　　　　圖 2

② 子午馬蟠橋
Coiled bridge palm with straight stance

動作要領: 接上一動作，向右橫開右子午馬，左掌蟠橋，與己心同高，右手握
扇於腰後，目視左掌方向（如圖 3）。

要　　求: 開橫馬要迅速

Movement:
Continue with previous action. Move to the right to form right transverse
straight stance. Coil left palm to the front. Left palm is as high as my side's
chest. Right hand is holding the fan at the back. Eyes are looking attentively at
the direction of left palm. (Fig.3)

Requirement:
Perform transverse straight stance rapidly

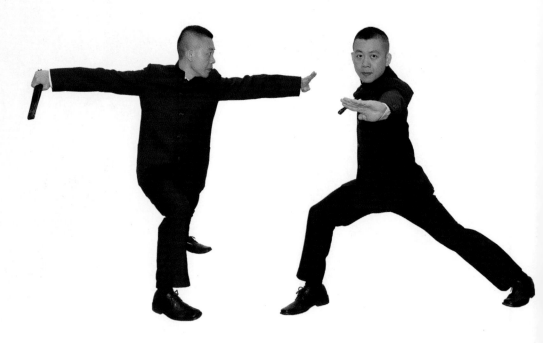

圖 3-1　　　　　　　　　　　　　　　　圖 3-2

 偏馬拋打
Throwing strike with transverse hanging stance

動作要領： 接上一動作，偏右左吊馬，右手握扇由右往左上方拋打，扇尖與己
　　　　　太陽穴同高，左掌於腰後，目視扇方向(如圖 4)。

要　　求： 勁達扇尖

Movement:
Continue with previous action. Perform left hanging stance in right transverse orientation. Right hand is holding the fan. Swing right hand from right to left-top position. Tip of fan is as high as my side's temple. Left palm is at the back. Eyes are looking attentively at the direction of fan. (Fig.4)

Requirement:
Power is reached the tip of fan

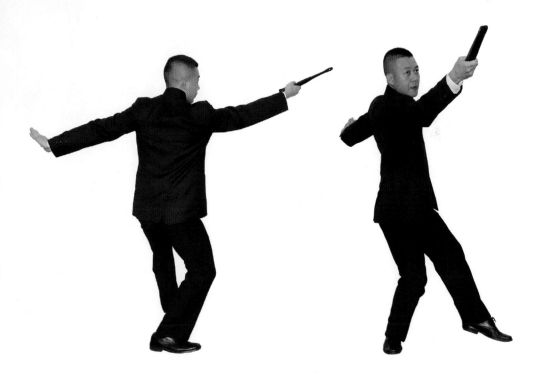

圖 4-1　　　　　　　　　　　　　　圖 4-2

應用

預備式(如圖5)，當敵方向我方頭部攻擊時，我方偷左馬卸其勢，吊右馬向敵方喉部標扇(如圖6)，敵方用手格擋時，我方即向右橫開右子午馬，左掌蟠橋偷出右手(如圖7)，再偏右左吊馬向敵方左邊太陽穴拋打(如圖8)。

要求

變招要快

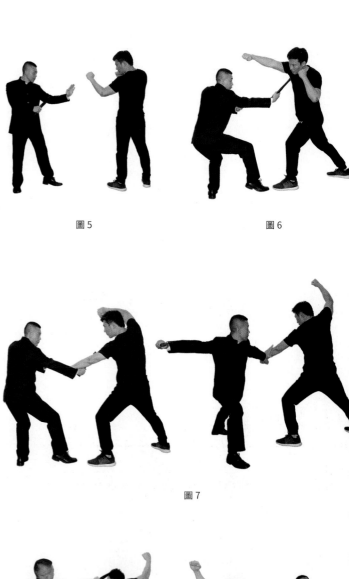

圖 5　　　　　　圖 6

圖 7

Application:

Ready position. (Fig.5) When opponent attacks my side's head, my side move left foot to the back to relieve the offense. Then, my side change to right hanging stance and strike the fan from bottom to top towards opponent's throat. (Fig.6) When opponent intercepts with hand, my side move to the right with transverse straight stance immediately and coil left palm to the front so as to spare right hand. (Fig.7) Then, perform throwing strike with left hanging stance in right transverse orientation to hit opponent's left temple. (Fig.8)

Requirement:

Change actions rapidly

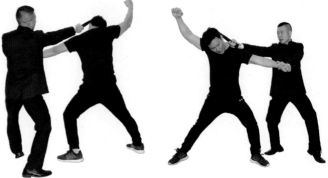

圖 8

子午馬割扇
箭指打腳

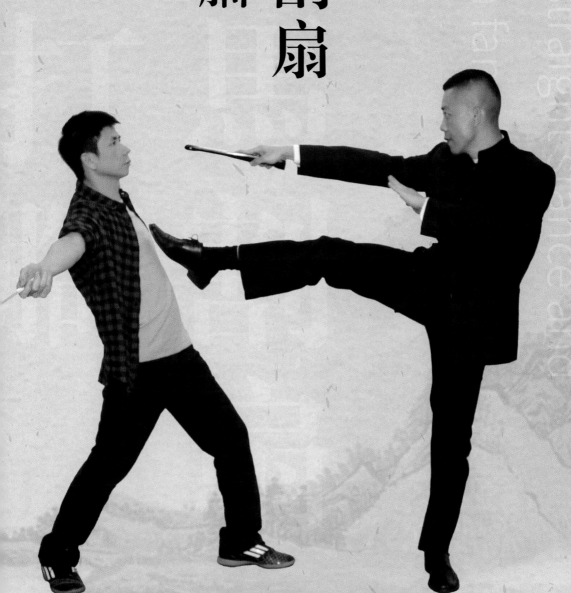

① 子午馬割扇
Fan cutting with straight stance

動作要領： 預備式(如圖 1)，向左進左橫子午馬，右手握扇掄臂，由上往下向前
方割打，扇尖以己肩同高，左掌於腰後，目視扇方向(如圖 2)。

要　　求： 勁貫扇身

Movement:

Ready position. (Fig.1) Move to the left with left transverse straight stance. Rotate right hand which is holding the fan from bottom to top and perform fan cutting to the front. The tip of fan is as high as my side's shoulder. Left palm is at the back. Eyes are looking attentively at the direction of fan. (Fig.2)

Requirement:

Power is ran through the fan

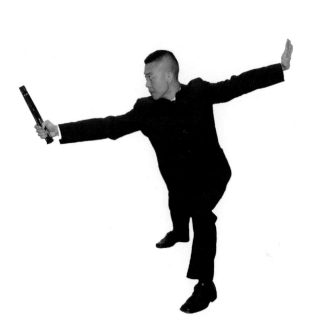

圖 1 　　　　　　　　　　圖 2

② 箭指打腳
Springing leg with fan

動作要領： 接上一動作，踢右腳，腳尖與己心口同高，同時右手握扇指向前方，扇尖與己眼同高，左掌護胖，目視扇方向（如圖3）。

要　　求： 扇和腳同時出擊

Movement:

Continue with previous action. Kick right foot to the front. The tip of foot is as high as my side's chest. At the same time, point right hand which is holding the fan to the front. Tip of fan is as high as my side's eyes. Place left palm next to right elbow for protection. Eyes are looking attentively at the direction of fan. (Fig.3)

Requirement:

Point the fan and kick the foot simultaneously

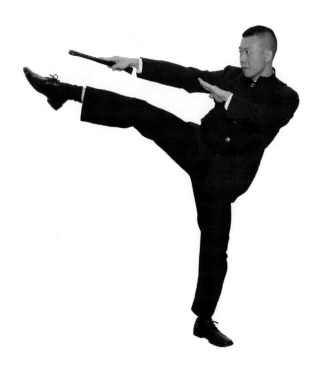

圖 3

應用

預備式 (如圖 4)，當敵方持短刀劈向我方頭部時，我方快速向左橫子午馬割扇，割打敵方手腕或前臂 (如圖 5)，成功截擊對方攻擊時，再用箭指打腳反擊敵方頭與心口，扇尖指向敵方眼部 (如圖 6)。

要求

變招要快

Application:

Ready position. (Fig.4) When opponent chops my side's head with a dagger, my side move to the left and perform fan cutting with transverse straight stance to strike opponent's wrist or forearm. (Fig.5) When my side intercept opponent's offense successfully, then perform springing leg with fan to hit opponent's head and chest. Point the tip of fan towards opponent's eyes. (Fig.6)

Requirement:

Change actions rapidly

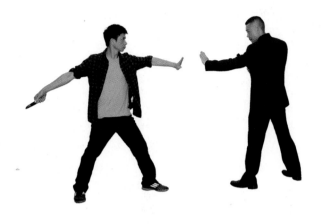

圖 4

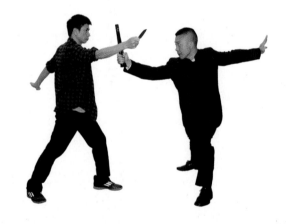

圖 5

圖 6

拐馬扣打
子午馬割扇

Buckle strike with transverse cross stance and
fan cutting with straight stance

 拐馬扣打
Buckle strike with transverse cross stance

動作要領： 預備式(如圖1)，向左橫拐右馬，同時右手握扇反手扣打，扇與己腰
腹同高，左掌護靜，目視扇方向(如圖2)。

要　　求： 勁達扇尖

Movement:
Ready position. (Fig.1) Move to the left with right transverse cross stance. At the same time, perform buckle strike with right hand which is holding the fan. The fan is as high as my side's waist/abdomen. Place left palm next to right elbow for protection. Eyes are looking attentively at the direction of fan. (Fig.2)

Requirement:
Power is reached the tip of fan

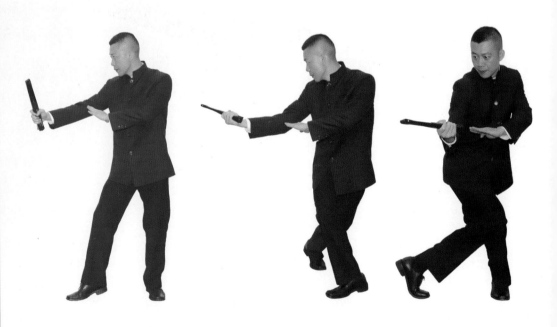

圖 1　　　　　　　　　　圖 2-1　　　　　　　　圖 2-2

 子午馬割扇
Fan cutting with straight stance

動作要領： 接上一動作，向左進橫左子午馬，右手握扇由上往下向前方掄臂
割打，扇尖與己肩同高，左掌於腰後，目視扇方向(如圖 3)。

要　　求： 掄臂有力

Movement:

Continue with previous action. Move to the left with left transverse straight
stance. Rotate right arm which is holding the fan from top to bottom to perform
fan cutting. Tip of fan is as high as my side's shoulder. Left palm is at the back.
Eyes are looking attentively at the direction of fan. (Fig.3)

Requirement:

Rotate arm forcefully

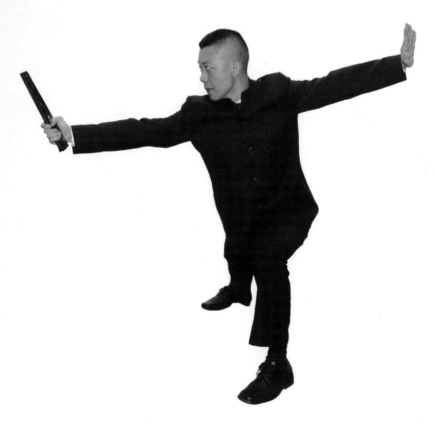

圖 3

應用

預備式(如圖4)，當敵方持短刀刺我方胸腹時，我方快速向左拐右馬，避開敵方攻勢，同時右手握扇扣打敵方手腕 (如圖5)，再進左子午馬向敵方頭部割打(如圖6)。

要求

變招要快

Application:

Ready position. (Fig.4) When opponent stabs my side's chest/abdomen with a dagger, my side move to the left rapidly with right transverse cross stance to evade opponent's offense. At the same time, perform buckle strike with right hand to hit opponent's wrist. (Fig.5) Then, move to the left with straight stance and perform fan cutting towards opponent's head. (Fig.6)

Requirement:

Change actions rapidly

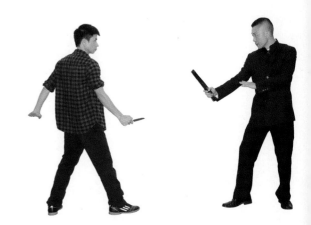

圖 4

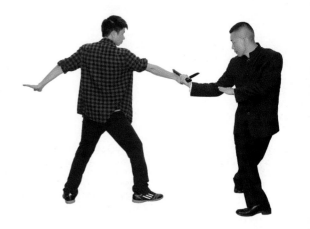

圖 5

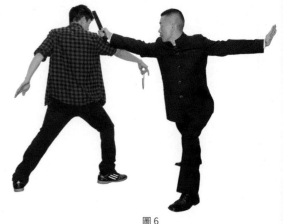

圖 6

傘

第二十一招 — 第二十四招

UMBRELLA
TWENTY-FIRST—
TWENTY-FOURTH

横子午馬摭攔
吊馬昂傘

Vertical interception with transverse straight stance
and elevating umbrella with hanging stance

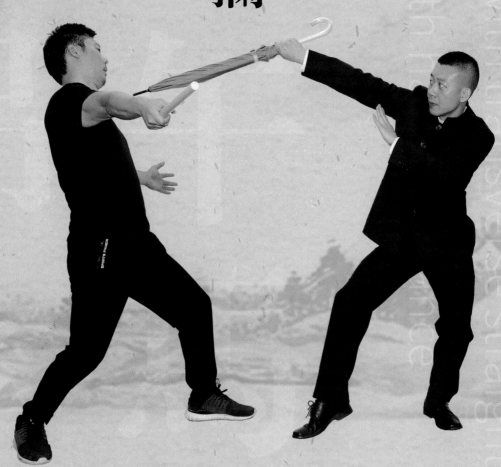

① 橫子午馬摭攔
Vertical interception with transverse straight stance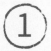

動作要領： 預備式(如圖1)，左腳向左移動開左橫子午馬，右手握傘柄向左橫摭
攔，傘尖垂直向上，左手護腕，目視右手前方(如圖2)。

要　　求： 勁貫傘身

Movement:
Ready position. (Fig.1) Move left foot to the left to form left transverse straight stance. Swing right hand which is holding the umbrella vertically from right to left. Place left palm next to right wrist for protection. Eyes are looking attentively at the direction of umbrella. (Fig.2)

Requirement:
Power is ran through the umbrella

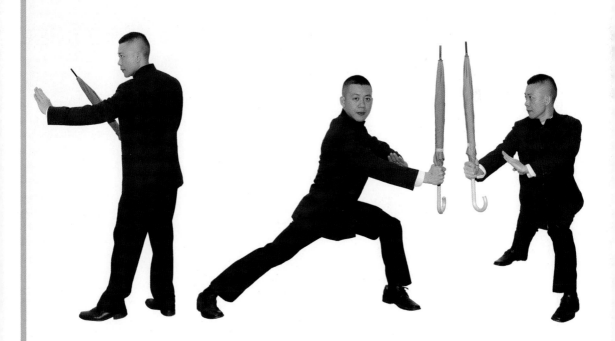

圖 1　　　　　　　　　　圖 2-1　　　　　　　　　　圖 2-2

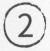

吊馬昂傘
Elevating umbrella with hanging stance

動作要領： 上一動作，吊右馬，右手由下往上反手昂傘，傘尖與己下巴同高，
左手護靜，目視前方(如圖 3)。

要　　求： 勁達傘尖

Movement:
Continue with previous action. Perform right hanging stance. Elevate right hand which is holding the umbrella from bottom to top to the level of my side's chin. Place left palm next to right elbow for protection. Eyes are looking attentively at the front. (Fig.3)

Requirement:
Power is reached the tip of umbrella

圖 3

應用

預備式（如圖4），當敵方持短棍劈向我方頭部時，我方快速開左橫子午馬攔擋，截打敵方前臂（如圖5），成功截擊對方攻擊時，再吊右馬昂傘，擊打敵方喉嚨或以上部位（如圖6）。

要求

變招要快

Application:

Ready position. (Fig.4) When opponent chops my side's head with a short stick, my side move to the left rapidly with transverse straight stance and perform vertical interception to strike opponent's forearm. (Fig.5) When my side intercept opponent's offense successfully, then change to right hanging stance and elevate the umbrella to hit opponent's throat or above parts. (Fig.6)

Requirement:

Change actions rapidly

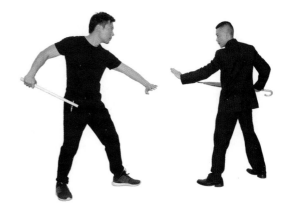

圖 4

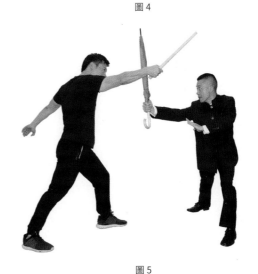

圖 5

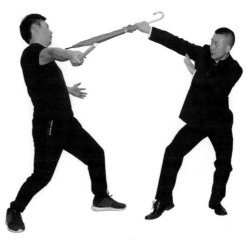

圖 6

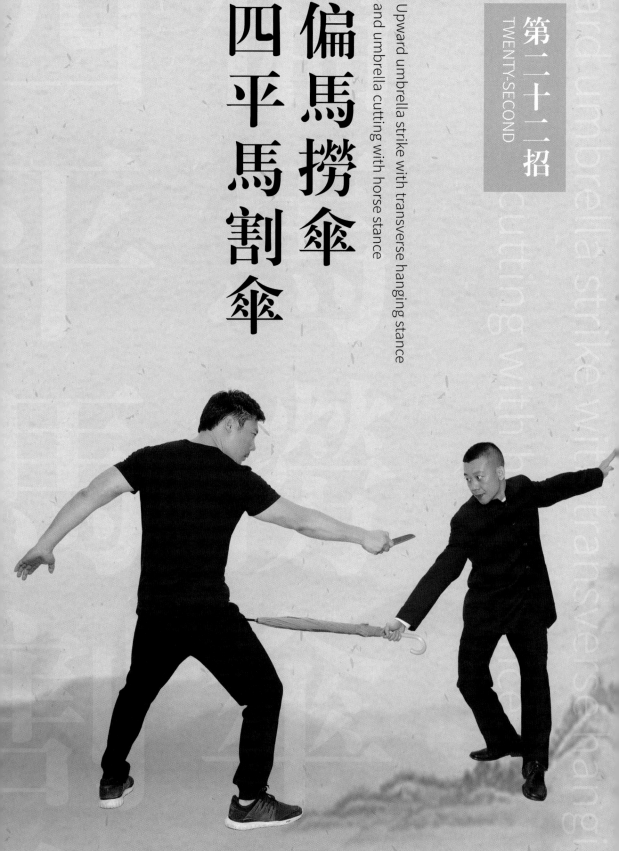

偏馬撈傘
四平馬割傘

Upward umbrella strike with transverse hanging stance
and umbrella cutting with horse stance

119

① 偏馬撈傘
Upward umbrella strike with transverse hanging stance

動作要領： 預備式(如圖 1)，右腳向右移動，偏右吊左馬，右手握傘由下往上撈傘，傘尖與己襠同高，目視前方(如圖 2)。

要　　求： 勁達傘尖

Movement:
Ready position. (Fig.1) Move right foot to the right to form left hanging stance in right transverse orientation. Swing right hand which is holding the umbrella from bottom to top. Tip of umbrella is as high as my side's lower part of the body. Eyes are looking attentively at the front.(Fig.2)

Requirement:
Power is reached the tip of umbrella

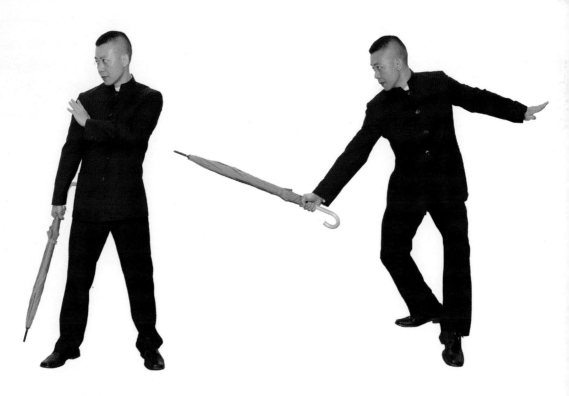

圖 1　　　　　　　　　　　　　　　　圖 2

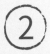

四平馬割傘
Umbrella cutting with horse stance

動作要領： 接上一動作，左腳向後移動成四平馬，右手握傘下割，傘尖與己額
同高，目視前方(如圖 3)。

要　　求： 勁貫傘身

Movement:

Continue with previous action. Move left foot to the back to form horse stance.
Lower right hand which is holding the umbrella to perform umbrella cutting.
The umbrella is as high as my side's forehead. Eyes are looking attentively at the
front. (Fig.3)

Requirement:

Power is ran through the umbrella

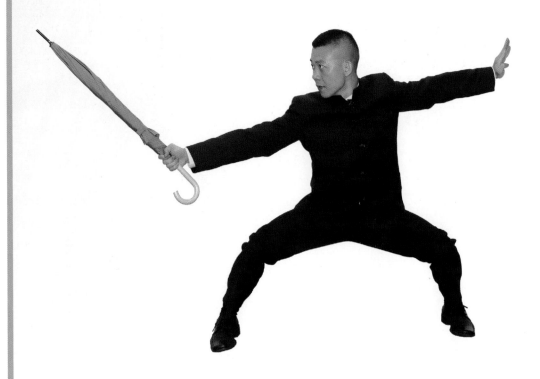

圖 3

應用

預備式（如圖 4），當敵方向我方
頭部攻擊時，我方可快速偏右
馬撈傘攻擊敵方襠部（如圖 5），
然後移動左腳四平馬向敵方
前臂或頭部割傘（如圖 6）。

要求

變招要快

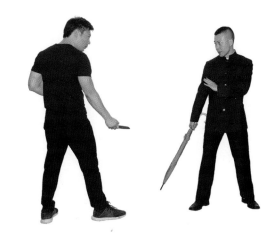

圖 4

Application:

Ready position. (Fig.4) When
opponent attacks my side's
head, my side may perform
upward umbrella strike with
left hanging stance in right
transverse orientation, to hit
opponent's lower part of the
body. (Fig.5) Then, my side
move left foot to the back and
perform umbrella cutting with
horse stance, to strike oppo-
nent's forearm or head. (Fig.6)

Requirement:

Change actions rapidly

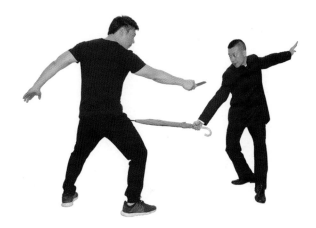

圖 5

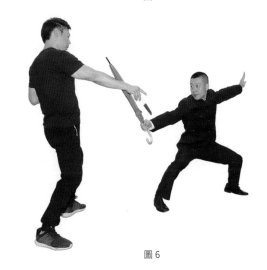

圖 6

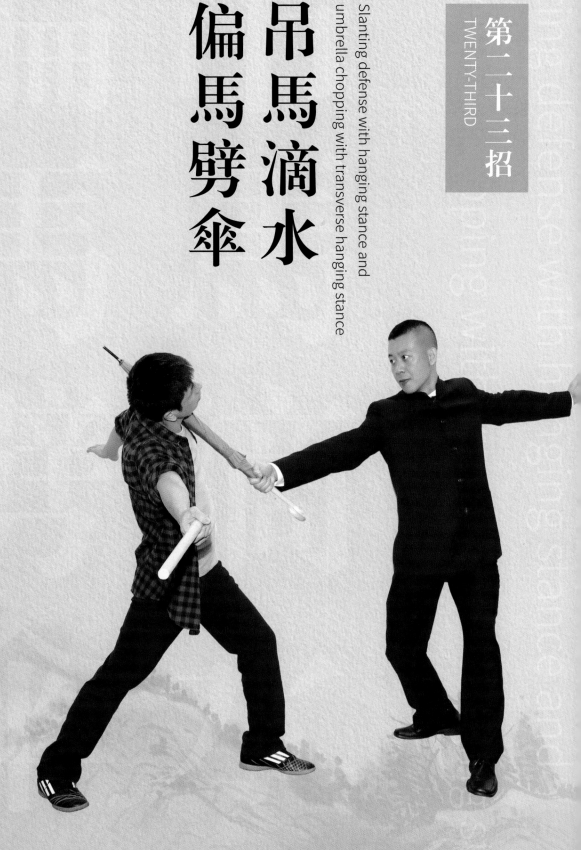

吊馬滴水
偏馬劈傘

Slanting defense with hanging stance and
umbrella chopping with transverse hanging stance

① 吊馬滴水
Slanting defense with hanging stance

動作要領： 預備式(如圖 1)，吊左馬，雙手握傘兩頭，右手上舉於頭上方，傘成
45 度角斜下，目視前方(如圖 2)。

要　　求： 雙手外撐有力

Movement:

Ready position. (Fig.1) Perform left hanging stance. Hold both ends of the umbrella with hands. Elevate right hand above head. The umbrella is obliquely downward at an angle of 45°. Eyes are looking attentively at the front. (Fig.2)

Requirement:

Hold the umbrella with forceful outward tension

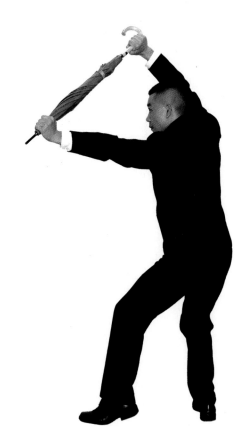

圖 1

圖 2

 偏馬劈傘
Umbrella chopping with transverse hanging stance

動作要領： 接上一動作，右腳向右移動，偏右吊左馬，右手握傘下劈，傘尖與
己額同高，目視前方 (如圖 3)。

要　　求： 勁貫傘身

Movement:
Continue with previous action. Move right foot to the right to form left hanging
stance in right transverse orientation. Chop down umbrella with right hand. Tip
of umbrella is as high as my side's forehead. Eyes are looking attentively at the
front. (Fig.3)

Requirement:
Power is ran through the umbrella

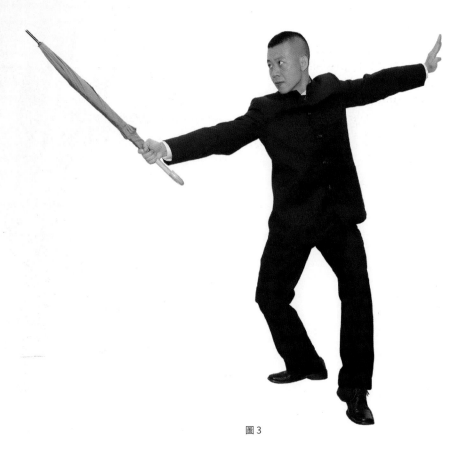

圖 3

應用

預備式(如圖4)，當敵方用短棍向我方頭部攻擊時，我方可快速舉傘用吊馬滴水截擋敵方攻勢(如圖5)，然後偏右馬向敵方頭頸部劈傘(如圖6)。

要求

變招要快

Application:

Ready position. (Fig.4) When opponent attacks my side's head with a short stick, my side may elevate the umbrella rapidly to perform slanting defense with hanging stance, to intercept opponent's offense. (Fig.5) Then, my side perform umbrella chopping with right transverse hanging stance towards opponent's head/neck. (Fig.6)

Requirement:

Change actions rapidly

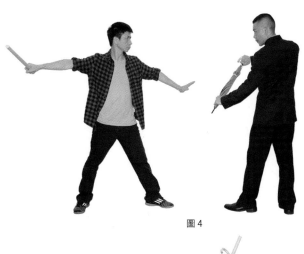

圖 4

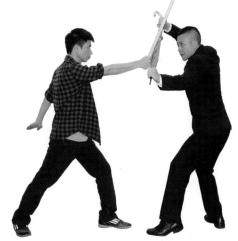

圖 5

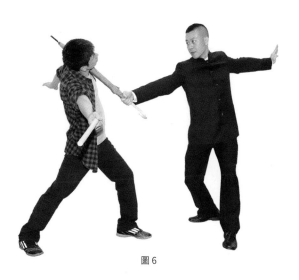

圖 6

拐馬單攔
捨馬割傘
反手笈打
進馬刺傘

Back horizontal umbrella with transverse cross stance
umbrella cutting with reversed straight stance
counterattack of reversed umbrella and
umbrella stabbing with straight stance

 拐馬單攔

Back horizontal umbrella with transverse cross stance

動作要領： 預備式(如圖1)，右腳向後拐馬，右手握傘單攔，傘與己肋部同高，左
　　　　　掌護肘，目視傘身方向(如圖2)。

要　　求： 勁貫傘身

Movement:

Ready position. (Fig.1) Move right foot to the back to form transverse cross
stance. Push right hand which is holding the umbrella to the back horizontally.
The umbrella is as high as my side's ribs. Place left palm next to right elbow for
protection. Eyes are looking attentively at the direction of umbrella. (Fig.2)

Requirement:

Power is ran through the umbrella

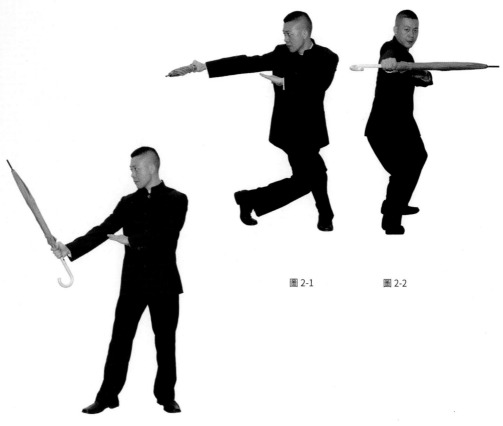

圖 2-1　　　　圖 2-2

圖 1

(2) 捨馬割傘
Umbrella cutting with reversed straight stance

動作要領: 接上一動作,雙手握傘,左腳向後捨馬,向後割傘,傘尖向後,雙臂
撐直,目視右方(如圖3)。

要　　求: 重心下沉

Movement:
Continue with previous action. Hands are holding the umbrella. Move left foot
to the back and perform umbrella cutting with reversed straight stance. Point
the tip of umbrella to the back. Straighten both arms. Eyes are looking atten-
tively to the right. (Fig.3)

Requirement:
Sink down center of gravity

圖 3

③ 反手笈打
Counterattack of reversed umbrella

動作要領： 接上一動作，捨馬不變，左手握傘向右前上方反手笈打，傘尖與己
頭同高，目視右前方(如圖 4)。

要　　求： 勁達傘尖

Movement:
Continue with previous action. Remain on reversed straight stance. Left hand is holding the umbrella. Perform counterattack of reversed umbrella on the right-front position. Tip of umbrella is as high as my side's head. Eyes are looking attentively at the right-front side. (Fig.4)

Requirement:
Power is reached the tip of umbrella

圖 4

 進馬刺傘
Umbrella stabbing with straight stance

動作要領： 接上一動作，進右子午馬，右刺傘，左手在後，兩臂成一直線，目視
　　　　　前方（如圖 5）。

要　　求： 勁達傘尖

Movement:
Continue with previous action. Move to the front with straight stance and stab
umbrella to the front. Left hand is at the back. Arms are in line. Eyes are looking
attentively at the front. (Fig.5)

Requirement:
Power is reached the tip of umbrella

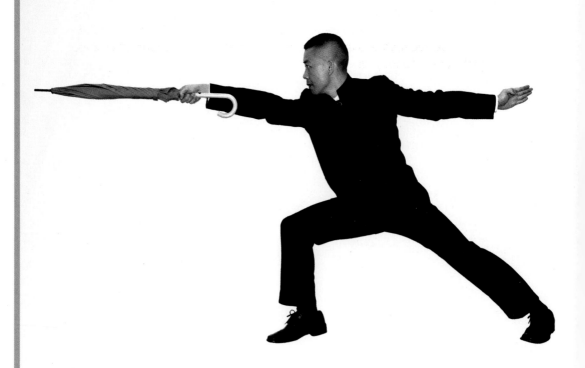

圖 5

應用

預備式(如圖6)，當敵方持短器械劈向我方頭部時，我方快速向後拐馬單攔擊打敵方肋部(如圖7)，如敵方能夠化解單攔，並再繼續攻擊我方頭部，我方即捨馬割打敵方手腕或前臂，如是有勾的傘，可用勾勾敵方手腕以脫敵方兵器(如圖8)，再用傘反手笯打敵方頭部(如圖9)，如敵方閃避，可再用進馬刺傘刺敵方胸部(如圖10)。

要求

變招要快

Application:

Ready position. (Fig.6) When opponent chops my side's head with short weapon, my side move back rapidly with transverse cross stance and perform back horizontal umbrella to hit opponent's ribs. (Fig.7) If opponent can resolve the back horizontal umbrella and continues to attack my side's head, my side perform umbrella cutting with reversed straight stance to strike opponent's wrist or forearm. If the umbrella has a hook, clasp opponent's wrist with the hook to remove opponent's weapon. (Fig.8) Then, my side perform counterattack of reversed umbrella towards opponent's head. (Fig.9) If opponent evades, stab the umbrella towards opponent' s chest. (Fig.10)

Requirement:

Change actions rapidly

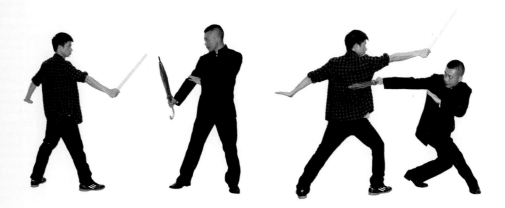

圖 6　　　　　　　　　　　　　　　　　　圖 7

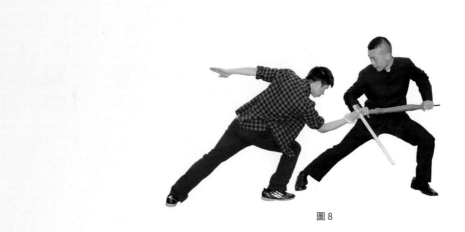

圖 8

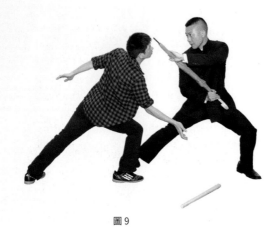

圖 9

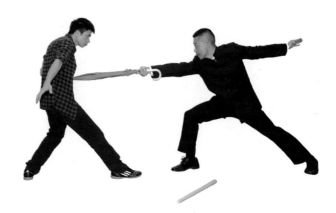

圖 10

棍
第二十五招
第二十八招

STICK
TWENTY-FIFTH——
TWENTY-EIGHTH

扭馬剎棍
四平馬衝棍

Downward strike with cross stance
and forward strike with horse stance

扭馬剎棍
Downward strike with cross stance

動作要領： 預備式(如圖 1)，左腳向前扭馬，左手握棍頭於左大腿旁，右手由上
　　　　　 往下拉剎棍，右手停於棍身三分一處，目視前方(如圖 2)。

要　　求： 勁貫棍身

Movement:
Ready position. (Fig.1) Move left foot to the front to form cross stance. Left hand
is holding one tip of the stick next to left leg. Slide down right hand from top to
bottom and stop at position which is one-third of the stick. Eyes are looking
attentively at the front. (Fig.2)

Requirement:
 Power is ran through the stick

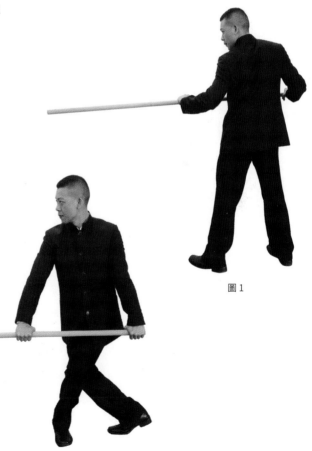

圖 1

圖 2

② 四平馬衝棍
Forward strike with horse stance

動作要領： 接上一動作，雙手拉棍(如圖3)，進右四平馬，右手握棍身中間，棍頭一尺處緊夾於左腋下，向前衝棍，目視前方(如圖4)。

要　　求： 勁達棍尖

Movement:

Continue with previous action. Slide both hands towards both tips respectively. (Fig.3) Move forward with right horse stance. Right hand is holding the middle part of stick. Clamp the stick under the left armpit and strike the stick to the front. Eyes are looking attentively at the front. (Fig.4)

Requirement:

Power is reached the tip of stick

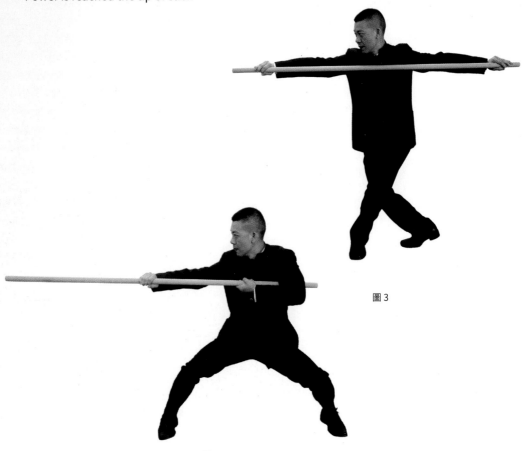

圖 3

圖 4

應用

預備式(如圖5)，敵方用刀攻擊我方頭部，我方即向敵方的刀身或握刀的手部扭馬剎棍(如圖6)，然後再進右四平馬向敵方腹部衝棍(如圖7)。

要求

變招要快

Application:

Ready position. (Fig.5) Opponent attacks my side's head with a knife, my side perform downward strike with cross stance towards the knife or opponent's hand which is holding the knife. (Fig.6) Then, my side perform forward strike with horse stance towards opponent's abdomen. (Fig.7)

Requirement:

Change actions rapidly

圖 5

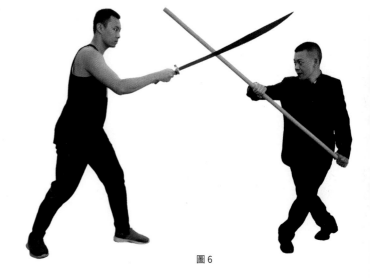

圖 6

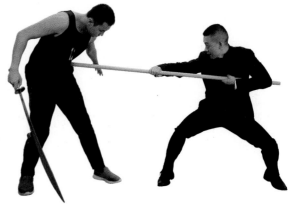

圖 7

吊馬鈀棍
四平馬冚棍

Lower backward interception with hanging stance
and push down with horse stance

第二十六招
TWENTY-SIXTH

吊馬鈀棍
Lower backward interception with hanging stance

動作要領： 預備式(如圖 1)，吊右馬，右手握棍身三分一處為支點，左手握棍頭
　　　　　　向左前方推出，棍尖向右斜下鈀，目視前方(如圖 2)。

要　　求： 勁達棍尖

Movement:

Ready position. (Fig.1) Perform right hanging stance. Right hand is holding the pivot at position which is one-third of the stick. Left hand is holding one tip of the stick. Push the stick to the left-front position so that another tip of the stick can intercept the right-bottom position. Eyes are looking attentively at the front. (Fig.2)

Requirement:

Power is reached the tip of stick

圖 1

圖 2

四平馬冚棍
Push down with horse stance

動作要領： 接上一動作，進右四平馬，左手握棍頭於左膝前，右手握棍身三分一處，由上往下冚棍，目視前方（如圖3）。

要　　求： 勁貫棍身

Movement:
Continue with previous action. Move to the right with horse stance. Left hand is holding the tip of the stick in front of left knee. Right hand is holding at position which is one-third of the stick. Push down the stick from top to bottom. Eyes are looking attentively at the front. (Fig.3)

Requirement:
Power is ran through the stick

圖 3

應用

預備式（如圖4），敵方用棍刺擊我方腿部，我方即向敵方的棍身鈀棍（如圖5），將敵方的棍撥開，然後再進右四平馬向敵方頭部冚棍（如圖6）。

要求

變招要快

Application:
Ready position. (Fig.4) Opponent stabs my side's leg with a stick, my side perform lower backward interception to repel opponent's stick. (Fig.5) Then, my side perform push down with horse stance towards opponent's head. (Fig.6)
Requirement:
Change actions rapidly

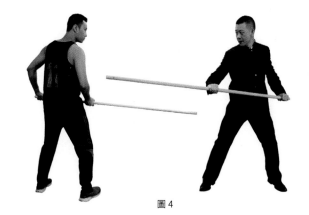

圖4

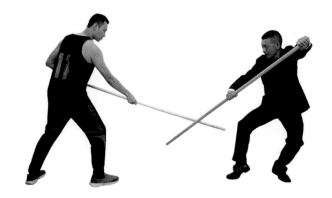

圖5

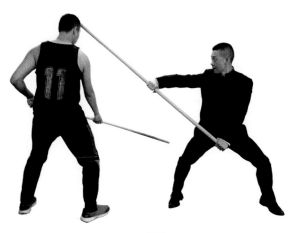

圖6

左右剎棍

Left downward strike and right downward strike

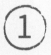 **右刹棍**
Right downward strike

動作要領： 預備式(如圖1)，開左腳左橫子午馬，左手握棍頭於左大腿旁(如圖2)，
右手握棍頭由上往下滑刹棍，右手停於棍身三分一處，棍身與地
面平行，目視前方(如圖3)。

要　　求： 以腰發勁

Movement:
Ready position. (Fig.1) Move left foot to the left to form left transverse straight
stance. Hold one tip of the stick with left hand and place next to left leg. (Fig.2)
Slide down right hand from top to bottom and stop at position which is
one-third of the stick. The stick is parallel to the ground. Eyes are looking atten-
tively at the front. (Fig.3)
Requirement:
Induce power form waist

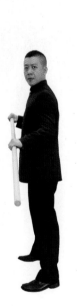

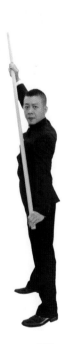

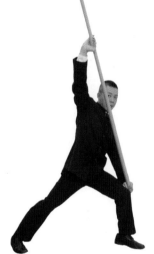

圖 3-1

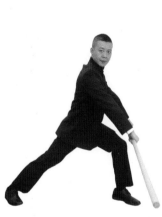

圖 3-2

圖 1

圖 2

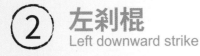

② 左刹棍
Left downward strike

動作要領： 接上一動作，進右橫子午馬，右手拉棍，握棍頭於右大腿旁（如圖4），
左手握棍頭由上往下滑刹棍，左手停於棍身三分一處，棍身與地
面平行，目視前方（如圖5）。

要　　求： 以腰發勁

Movement:
Continue with previous action. Move to the right with transverse straight stance.
Hold one tip of the stick with right hand and place next to right leg. (Fig.4) Slide
down left hand from top to bottom and stop at position which is one-third of
the stick. The stick is parallel to the ground. Eyes are looking attentively at the
front. (Fig.5)

Requirement:
Induce power form waist

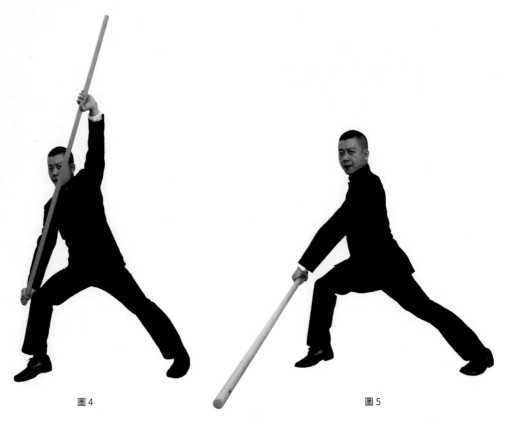

圖4　　　　　　　　　　　　　　　　　　　　圖5

應用

預備式(如圖6)，敵方用刀攻擊我方頭部，我方即開左橫子午馬向刀身右刹棍(如圖7)，然後再進右橫子午馬向敵方頭部左刹棍(如圖8)。

要求

變招要快

Application:

Ready position. (Fig.6) Opponent attacks my side's head with a knife, my side perform right downward strike with left transverse straight stance towards the knife. (Fig.7) Then, my side perform left downward strike with right transverse straight stance towards opponent's head. (Fig.8)

Requirement:

Change actions rapidly

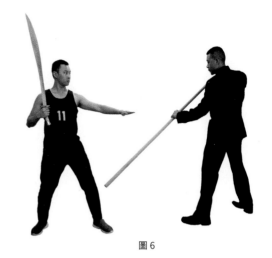

圖 6

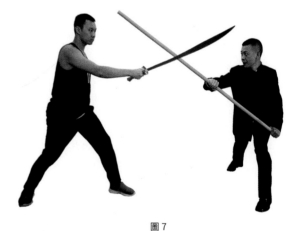

圖 7

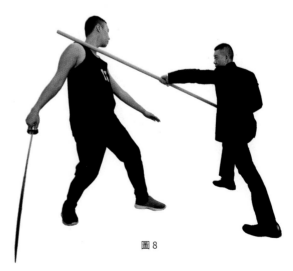

圖 8

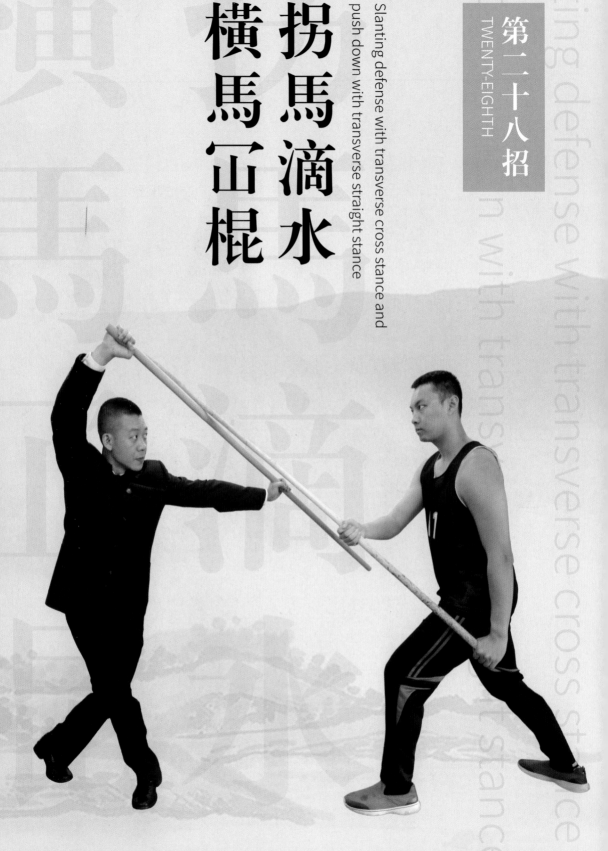

拐馬滴水
橫馬冚棍

Slanting defense with transverse cross stance and push down with transverse straight stance

149

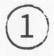

拐馬滴水
Slanting defense with transverse cross stance

動作要領： 預備式（如圖1），右腳向前拐馬，左手握棍中間，右手握棍頭上舉於
頭上方，棍成45度角斜下，目視前方（如圖2）。

要　　求： 雙手外撐有力

Movement:
Ready position. (Fig.1) Move right foot to the front to form transverse cross stance. Hold the middle part of the stick with left hand. Elevate right hand which is holding one tip of the stick. The stick is obliquely downward at an angle of 45°. Eyes are looking attentively at the front. (Fig.2)

Requirement:
Hold the stick with forceful outward tension

圖1

圖2

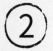

橫馬圎棍
Push down with transverse straight stance

動作要領： 接上一動作,左腳向左橫開右子午馬,左圎棍,目視前方(如圖 3)。
要　　求： 勁貫棍身

Movement:
Continue with previous action. Move left foot to the left to form right transverse straight stance. Push down the stick to the left. Eyes are looking attentively at the front. (Fig.3)

Requirement:
Power is ran through the stick

圖 3

應用

預備式(如圖4)，敵方主動用棍向我方頭部攻擊，我方即用拐馬滴水擋截敵方攻勢 (如圖 5)，然後再移動左橫馬向敵方頭頸部冚棍(如圖6)。
要求：變招要快

要求

變招要快

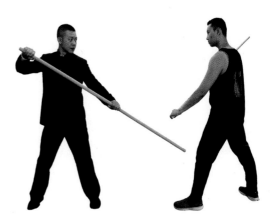

圖 4

Application:

Ready position. (Fig.4) Opponent attacks my side's head with a stick actively, my side perform slanting defense with transverse cross stance to intercept opponent's offense. (Fig.5) Then, my side move to the left with transverse straight stance and push down the stick to strike opponent's head/neck. (Fig.6)

Requirement:

Change actions rapidly

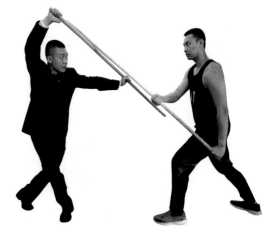

圖 5

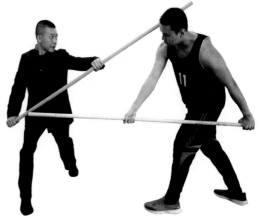

圖 6

國際武術大講堂系列教程之一
《 蔡李佛技擊法 》
編著: 黃宇帆

翻譯 : 蔡茂龍 Richard Yeung

攝影 : 黃子龍 劉顯燦

設計 : 黃文導

總編輯: 冷先鋒

香港國際武術總會有限公司 出版

香港聯合書刊物流有限公司 發行

香港地址: 香港九龍彌敦道525 -543號寶寧大廈C座412室

電話: 00852-98500233 \ 91267932 \ 98103192

Email : info@wyf.hk Facebook 專頁 : wyfkungfu

網站: https:// www.wyf.hk https://taijiyanghk.com

印次 : 2020年12月第一次印刷 印數: 2000冊

ISBN : 978-988-75077-6-5

定價 : HKD 198.00